The Art of Painting Still Life in Acrylic

Walter Foster

© 2015 Quarto Publishing Group USA Inc.
Artwork on front cover (center) and pages 3, 4, 6, 16, 18–53 © Varvara Harmon. Artwork on front cover (top right) and pages 80, 82–107 © Elizabeth Mayville. Artwork on front cover (bottom right), back cover, and pages 54, 56–79 © Janice Robertson. Artwork on pages 1, 108, 110–139 © Tracy Meola. Photographs on pages 8 ("Mediums & Additives"), 9 ("Surfaces"), 10–11, and 14–15 © Elizabeth T. Gilbert. Artwork and photographs on pages 12–13
© Vanessa Rothe. Photographs on pages 8 ("Acrylic Paint" and "Palettes") and 9 ("Brushes" and "Additional Supplies") © Shutterstock. Artwork on page 10 ("Color Temperature") © Robert Moore.

First published in 2015 by Walter Foster Publishing, an imprint of The Quarto Group.
26391 Crown Valley Parkway, Suite 220, Mission Viejo, CA 92691, USA.
T (949) 380-7510 F (949) 380-7575 **www.QuartoKnows.com**

Walter Foster Publishing titles are also available at discount for retail, wholesale, promotional, and bulk purchase. For details, contact the Special Sales Manager by email at specialsales@quarto.com or by mail at The Quarto Group, Attn: Special Sales Manager, 100 Cummings Center, Suite 265D, Beverly, MA 01915, USA.

ISBN: 978-1-63322-087-4

Authors: Varvara Harmon, Elizabeth Mayville, Tracy Meola, and Janice Robertson
Project Editor: Elizabeth T. Gilbert
Page Layout: Britta Bonette

10 9 8 7 6 5 4 3 2 1

The Art of
Painting Still Life
in Acrylic

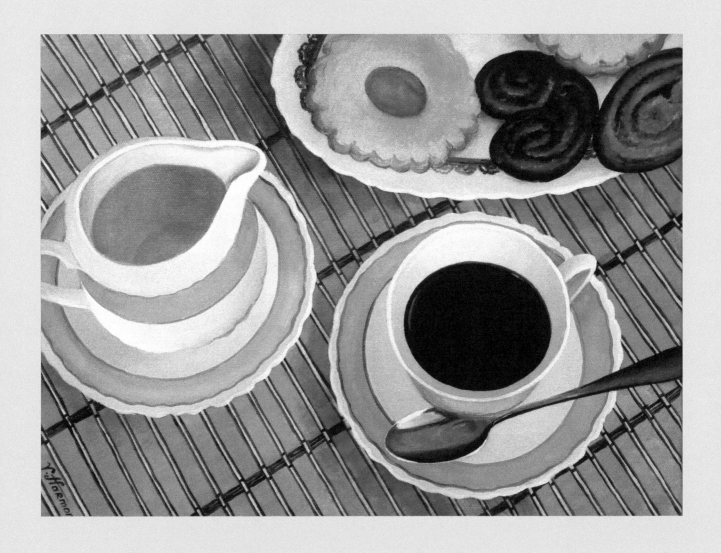

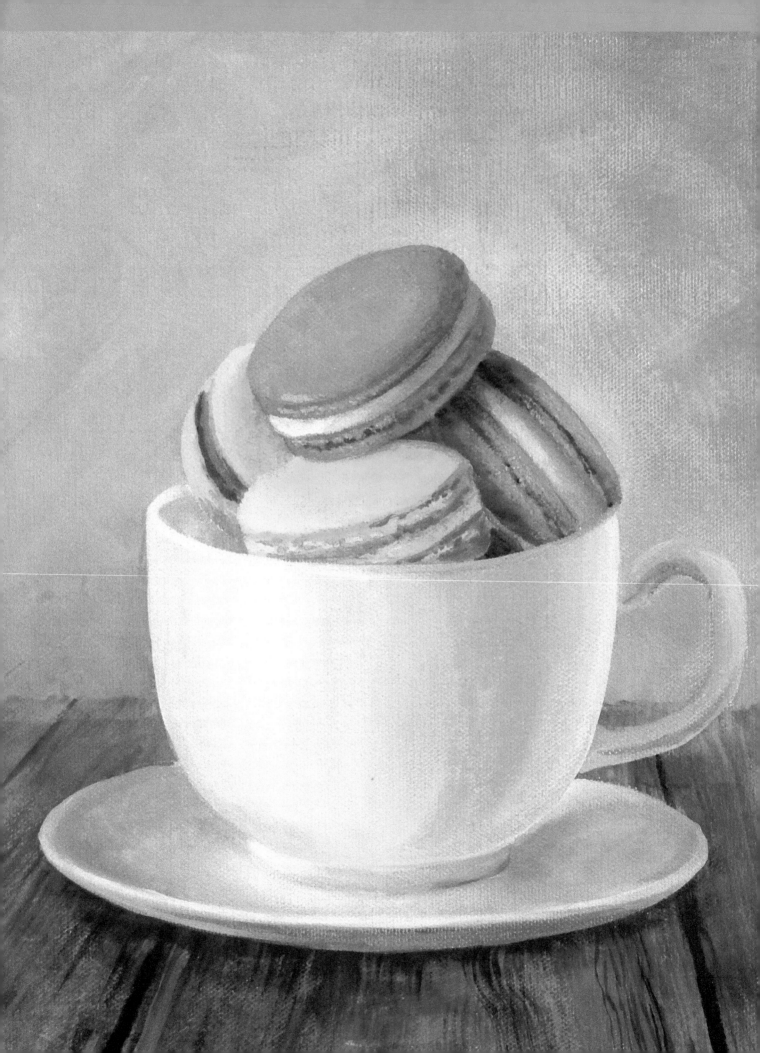

Contents

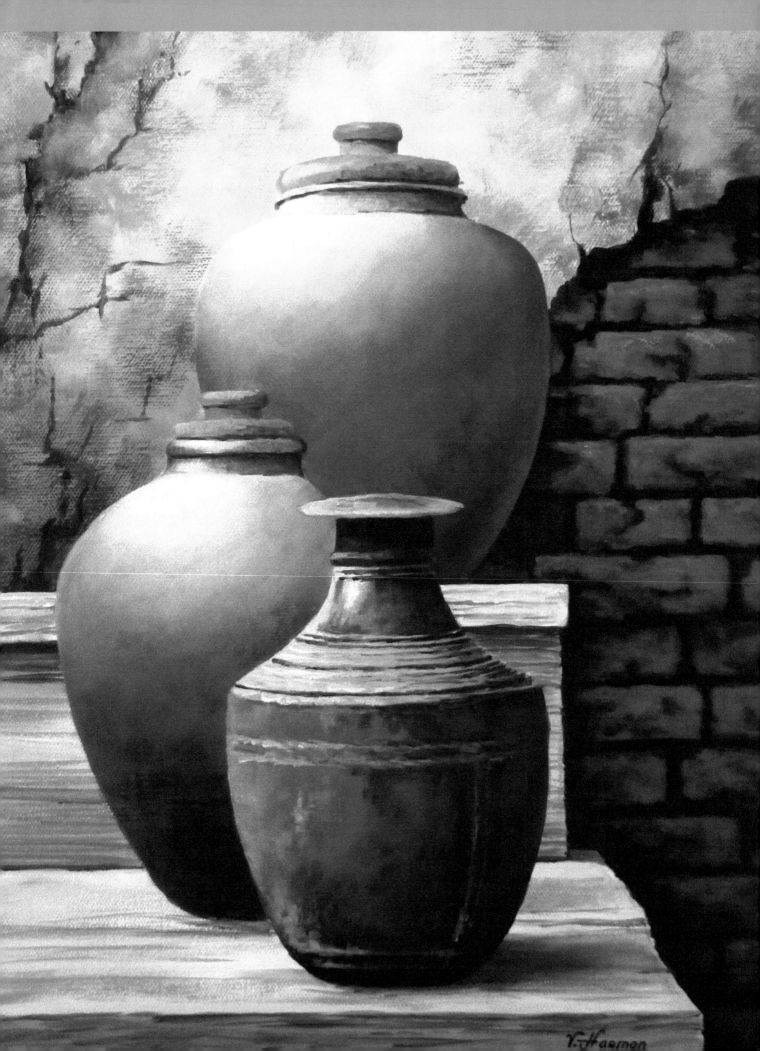

Introduction

A time-tested genre, still life painting focuses on the simple beauty of everyday scenes and objects. From gorgeous floral setups to cozy kitchen scenes, this book includes a range of lovely subjects to re-create in acrylic. Before you begin the step-by-step projects, it's important to acquaint yourself with the materials and techniques you'll be using. The following chapter covers everything from paints and brushes to color theory and basic drawing, giving you invaluable information as you lift your painting skills to the next level.

Tools & Materials

The vast array of art materials available to artists today can overwhelm beginning and experienced artists alike. The following pages will help you simplify the process of setting up an acrylic workspace. This versatile paint is water-based and nontoxic, so you'll need only a small selection of materials.

ACRYLIC PAINT

Acrylic is a water-based paint consisting of pigment in a binder of acrylic polymer emulsion. It comes in tubes, tubs, jars, and squeeze bottles. Tubes are generally used for higher-quality, artist-grade paints. You can dilute acrylic with plain water (no solvents needed!), but once it's dry, the paint is waterproof. You can apply the paint in thin or thick layers, imitating both watercolor and oil paint. But unlike oil, acrylic dries quickly so you don't have to wait long between layers.

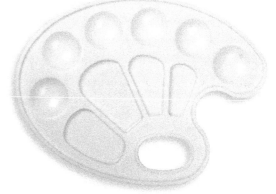

PALETTES

Palettes for acrylic paints are available in many different materials—from wood and ceramic to metal and glass. Plastic palettes are inexpensive, and they can be cleaned with soap and water.

MEDIUMS & ADDITIVES

To thin and clean up acrylic, water is the simplest medium. However, you can also find mediums and additives made specifically for acrylic. A range of gels, pastes, and additives allow artists to alter the behavior and properties of acrylic paint, such as extending the drying time or creating a coarse texture.

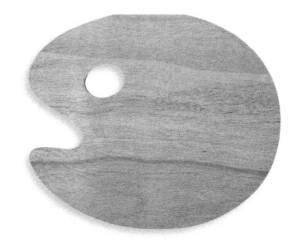

BRUSHES

Synthetic brushes are the best choice for acrylic painting because their strong filaments can withstand the caustic nature of acrylic. Sable and soft-hair synthetic brushes are ideal for watercolor. A selection of hog bristle brushes is a staple for all oil painters. Build your starter set with small, medium, and large flat brushes; a few medium round brushes; a liner (or rigger) brush; a medium filbert brush; and a medium fan brush. Brushes are commonly sized with numbers, although the exact sizes vary between manufacturers. Generally #1 to #5 are small brushes, #6 to #10 are medium brushes, and #11 and up are large brushes. Flat brushes are often sized by the width of the ferrule (or brush base), such as 1/4-inch, 1/2-inch, and 1-inch flat brushes.

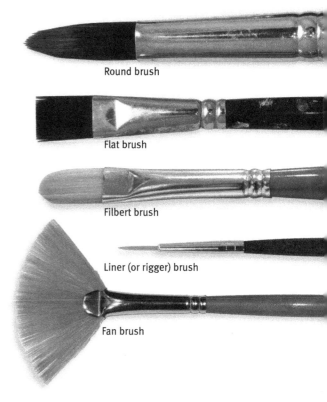

Round brush

Flat brush

Filbert brush

Liner (or rigger) brush

Fan brush

SURFACES

Acrylic paint needs a "toothy," porous, absorbent surface to which it can bind and adhere. For this reason, many surfaces need to be primed first to accept the paint. The most common primer is gesso, which prepares your surface to accept subsequent layers of paint. The most popular acrylic painting surfaces are pictured at right.

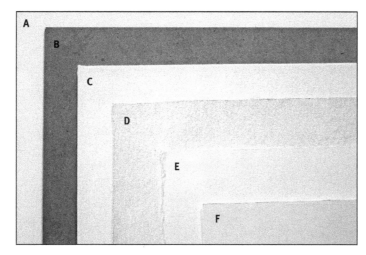

Traditional painting surfaces:
A. Canvas paper
B. Masonite or hardboard
C. Pre-primed canvas panels
D. Canvas
E. Watercolor paper
F. Primed mat board

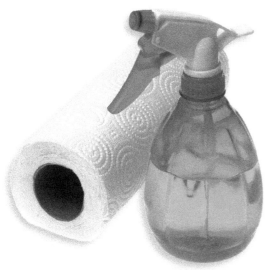

ADDITIONAL SUPPLIES

Some additional supplies you'll want to have on hand include:

- Paper, pencils, and a sharpener for drawing, sketching, and tracing
- Jars of water, paper towels, and a spray bottle of water
- Fixative to protect your initial sketches before you apply paint
- Palette knife to mix large quantities of paint or to apply paint creatively to your surface.

Color Theory

Acquaint yourself with the ideas and terms of color theory, which involve everything from color relationships to perceived color temperature and color psychology. In the following pages, we will touch on the basics as they relate to painting.

COLOR WHEEL

The color wheel, pictured to the right, is the most useful tool for understanding color relationships. Where the colors lie relative to one another can help you group harmonious colors and pair contrasting colors to communicate mood or emphasize your message. The wheel can also help you mix colors efficiently. Below are the most important terms related to the wheel.

Primary colors are red, blue, and yellow. With these you can mix almost any other color; however, none of the primaries can be mixed from other colors. Secondary colors include green, orange, and violet. These colors can be mixed using two of the primaries. (Blue and yellow make green, red and yellow make orange, and blue and red make violet.) A tertiary color is a primary mixed with a near secondary, such as red with violet to create red-violet.

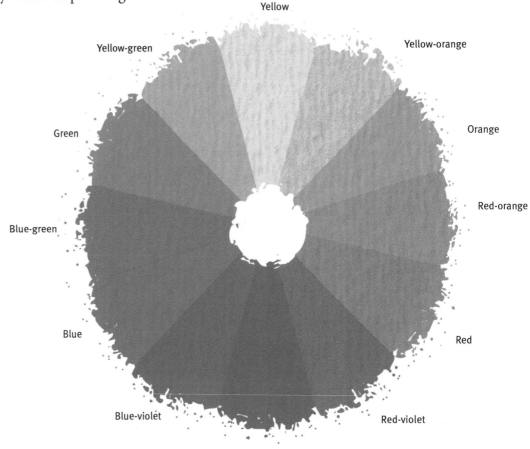

COMPLEMENTARY COLORS

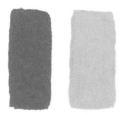

Complementary colors are those situated opposite each other on the wheel, such as purple and yellow. Complements provide maximum color contrast.

ANALOGOUS COLORS

Analogous colors are groups of colors adjacent to one another on the color wheel, such as blue-green, green, and yellow-green. When used together, they create a sense of harmony.

NEUTRAL COLORS

Neutral colors are browns and grays, both of which contain all three primary colors in varying proportions. Neutral colors are often dulled with white or black. Artists also use the word "neutralize" to describe the act of dulling a color by adding its complement.

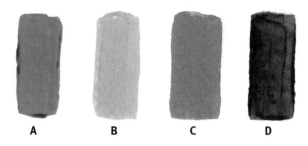

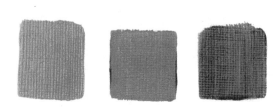

A *hue* is a color in its purest form (A), a color plus white is a *tint* (B), a color plus gray is a *tone* (C), and a color plus black is a *shade* (D).

A single color family, such as blue, encompasses a range of hues—from yellow-leaning to red-leaning.

COLOR & VALUE

Within each hue, you can achieve a range of values—from dark shades to light tints. However, each hue has a value relative to others on the color wheel. For example, yellow is the lightest color and violet is the darkest. To see this clearly, photograph or scan a color wheel, and use computer-editing software to view it in grayscale. It is also very helpful to create a grayscale chart of all the paints in your palette so you know how their values relate to one another.

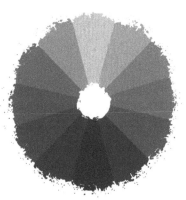

A grayscale representation of a color wheel can help you see the inherent value of each hue.

VALUE RELATIVITY

Values are perceived relative to others in the same scene. A color may appear dark against a white surface or light tint, but the same color may appear light against a dark surface. Above are middle-value strokes of purple over light and dark backgrounds. The same value can appear very different depending on its surroundings.

COLOR TEMPERATURE

Color temperature refers to the feeling one gets when viewing a color or set of colors. Generally, yellows, oranges, and reds are considered warm, whereas greens, blues, and purples are considered cool. When used within a work of art, warm colors seem to advance toward the viewer, and cool colors appear to recede into the distance. This dynamic is important to remember when suggesting depth or creating an area of focus.

The paintings to the right by artist Robert Moore illustrate warm and cool palettes. Compare the energy and glow of the yellow and orange autumn scene (A) to the soothing blues and purples of the tea still life (B). However, notice hints of contrasting temperatures in the scenes that create effective accents, such as the patches of cool blue sky and the warm teacup.

Artist's Tip

Art & craft stores sell spinning, handheld color wheels for painters that serve as color mixing guides. The wheels also show a range of gray values for reference.

Drawing Techniques

While the focus of this book is on painting, it's important to hone your drawing skills so you can set yourself up for a successful painting from the start.

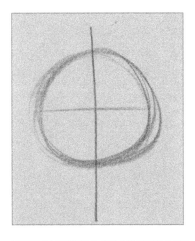
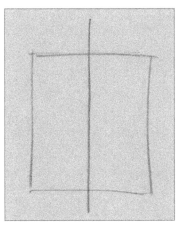

USING A CENTERLINE

Using a centerline when drawing shapes can help you achieve accurate measurements and symmetry. Before sketching a basic shape, draw a vertical and/or horizontal line; then use the guideline to draw your shape, making sure it is equal on both sides. Remember: Drawing straight lines and uniform circles takes practice and time. As you progress as an artist, these basic skills will improve.

ESTABLISHING PROPORTIONS

To achieve a sense of realism in your work, it's important to establish correct proportions. Using centerlines, as shown above, will provide starter guidelines. From there, you must delineate the shape of the object. To do this accurately, measure the lengths, widths, and angles of your subject. Examine the vertical, horizontal, and diagonal lines in your subject and make sure they relate properly to one another in your drawing. You can check proportions and angles by using your pencil as a measuring tool. Use the top of your thumb to mark where the measurement ends on your pencil (A, B), or hold it at an angle to check your angles (C, D).

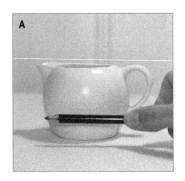
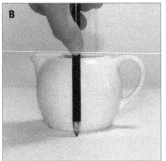
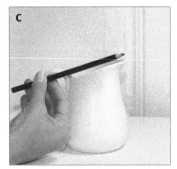
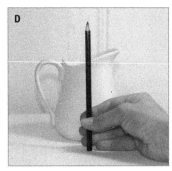

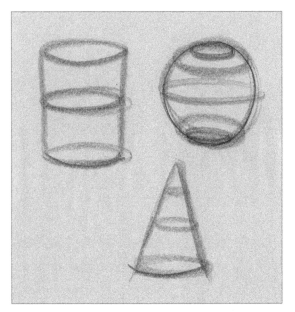

DRAWING THROUGH

You can transform basic shapes into forms by "drawing through" them. Imagine the form is transparent, and then suggest the surface of the backside in your sketch. This process will help you acknowledge the volume of your object as you add the surface shadows in later stages. It will also help you understand your object as it relates to its surroundings.

VALUES & SHADOWS

There are five main aspects of value that are used to create the illusion of volume. As mentioned previously, value refers to the tones of lightness and darkness, covering the full range of white through shades of gray to black. The range of lights and darks of an object can change depending on how much light hits the object. With practice, you will develop a keen eye for seeing lights, darks, and the subtle transitions between each value across a form. The five main values to look for on any object are the *cast shadow*, *core shadow*, *midtone*, *reflected light*, and *highlight*, as illustrated at right.

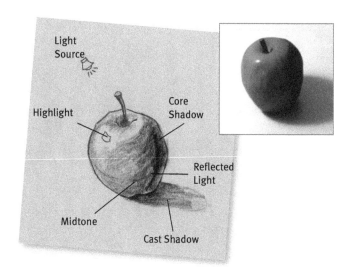

1. **Cast Shadow** This is the shadow of the object that is cast upon another surface, such as the table.
2. **Core Shadow** This refers to the darkest value on the object, which is located on the side opposite the light source.
3. **Midtone** This middle-range value is located where the surface turns from the light source.
4. **Reflected Light** This light area within a shadow comes from light that has reflected off of a different surface nearby (most often from the surface on which the object rests). This value depends on the overall values of both surfaces and the strength of the light, but remember that it's always darker than the midtone.
5. **Highlight** This refers to the area that receives direct light, making it the lightest value on the surface.

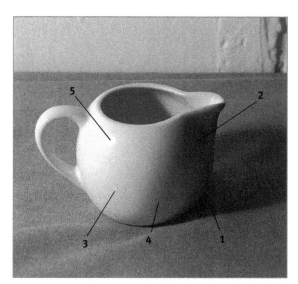

FOCUSING ON CAST SHADOWS

Every object casts a shadow onto the table, chair, or surface that it sits upon (called the "cast shadow" as explained above). The shadow will fall to and under the dark side of the object, away from the light source. Including this shadow is very important both in depicting the illusion of form and in grounding your object, which gives the viewer a sense of weight and space. Note that these shadows are the darkest at the point where they meet the object (often beneath the object) and lighten as they move away from the object. Generally the shadow edge is also sharpest at the base of the object, softening as it moves away from the object.

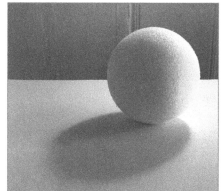

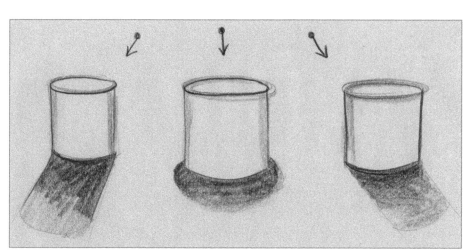

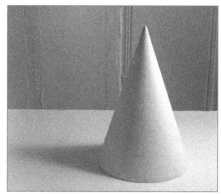

Acrylic Painting Techniques

Learn to manipulate acrylic paint to create a wide range of strokes, textures, and interesting effects. The following pages show you some of the most common techniques, but experimentation shouldn't stop here—try coming up with your own unique methods for applying paint!

WORKING WITH PAINTING TOOLS

The way you hold your tool, how much paint you load on it, the direction you turn it, and the way you manipulate it will all determine the effect of your stroke. The type of brush you use also has an effect; bristle brushes are stiff and hold a generous amount of paint. They are also excellent for covering large areas or for scrubbing in underpaintings. Soft-hair brushes (such as sables) are well suited for soft blends, glazes, and intricate details.

Flat Wash To create a thin wash of flat color, thin the paint and stroke it evenly across your surface. For large areas, stroke in overlapping horizontal bands, retracing strokes when necessary to smooth out the color. Use thinned acrylic for toning your surface or using acrylic in the style of watercolor.

Drybrushing Load your brush, and then dab the bristles on a paper towel to remove excess paint. Drag the bristles lightly over your surface so that the highest areas of the canvas or paper catch the paint and create a coarse texture. The technique works best when used sparingly and when used with opaque pigments over transparents.

Glazing As with watercolor, you can apply a thin layer of acrylic or oil over another color to optically mix the colors. Soft gels are great mediums for creating luminous glazes. Shown here are ultramarine blue (left) and lemon yellow (right) glazed over a mix of permanent rose and Naples yellow.

Dabbing Load your brush with thick paint and then use press-and-lift motions to apply irregular dabs of paint to your surface. For more depth, apply several layers of dabbing, working from dark to light. Dabbing is great for suggesting foliage and flowers.

Graduated Blend To create a gradual blend of one color into another, stroke the two different colors onto the canvas horizontally, leaving a gap between them. Continue to stroke horizontally, moving down with each stroke to pull one color into the next. Retrace your strokes where necessary to create a smooth blend between colors.

Scumbling This technique refers to a light, irregular layer of paint. Load a brush with a bit of slightly thinned paint, and use a scrubbing motion to push paint over your surface. When applying opaque pigments over transparents, this technique creates depth.

Artist's Tip

Use an old, dull pizza cutter to make straight lines; just roll it through the paint and then onto the support.

Painting Knife Applying paint with a painting knife can result in thick, lively strokes that feature variations in color, value, and height.

Scraping Create designs within your paint by scraping away paint. Using the tip of a painting knife or the end of a brush handle, "draw" into the paint to remove it from the canvas. For tapering strokes that suggest grass, stroke swiftly and lift at the end of each stroke.

Spattering First cover any area that you don't want to spatter with a sheet of paper. Load your brush with thinned paint, and tap it over a finger to fling droplets of paint onto the paper. You can also load your brush and then run a fingertip over the bristles to create a spray.

Stippling This technique involves applying small, closely placed dots of paint. The closer the dots, the finer the texture and the more the area will take on the color and tone of the stippled paint. You can also use stippling to optically mix colors; for example, stippling blue and yellow in an area can create the illusion of green.

Sponging Applying paint by dabbing with a sponge can create interesting, spontaneous shapes. Layer multiple colors to suggest depth. Remember that you can also use sponges to apply flat washes with thinned paint.

Wiping Away Use a soft rag or paper towel to wipe away wet paint from your canvas. You can use this technique to remove mistakes or to create a design within your work. Remember that staining pigments, such as permanent rose (above with Naples yellow), will leave behind more color than nonstaining pigments.

Thick on Thin Stroking a thick application of paint over a thin wash, letting the undercolor peek through, produces textured color variances perfect for rough or worn surfaces.

Impasto Use a paintbrush or painting knife to apply thick, varied strokes, creating ridges of paint. This technique can be used to punctuate highlights in a painting.

Mask with Tape Masking tape can be placed onto and removed from dried acrylic paint without causing damage. Don't paint too thickly on the edges—you won't get a clean lift.

Lifting Out Use a moistened brush or a tissue to press down on a support and lift color out of a wet wash. If the wash is dry, wet the desired area, and lift out with a paper towel.

BLENDING LARGE AREAS

A hake brush is handy for blending large areas. While the area is still wet, use a clean, dry hake to lightly stroke back and forth over the color. Be sure to remove any stray hairs before the paint dries and never clean your hake in thinner until you're done painting, as it will take a long time to dry.

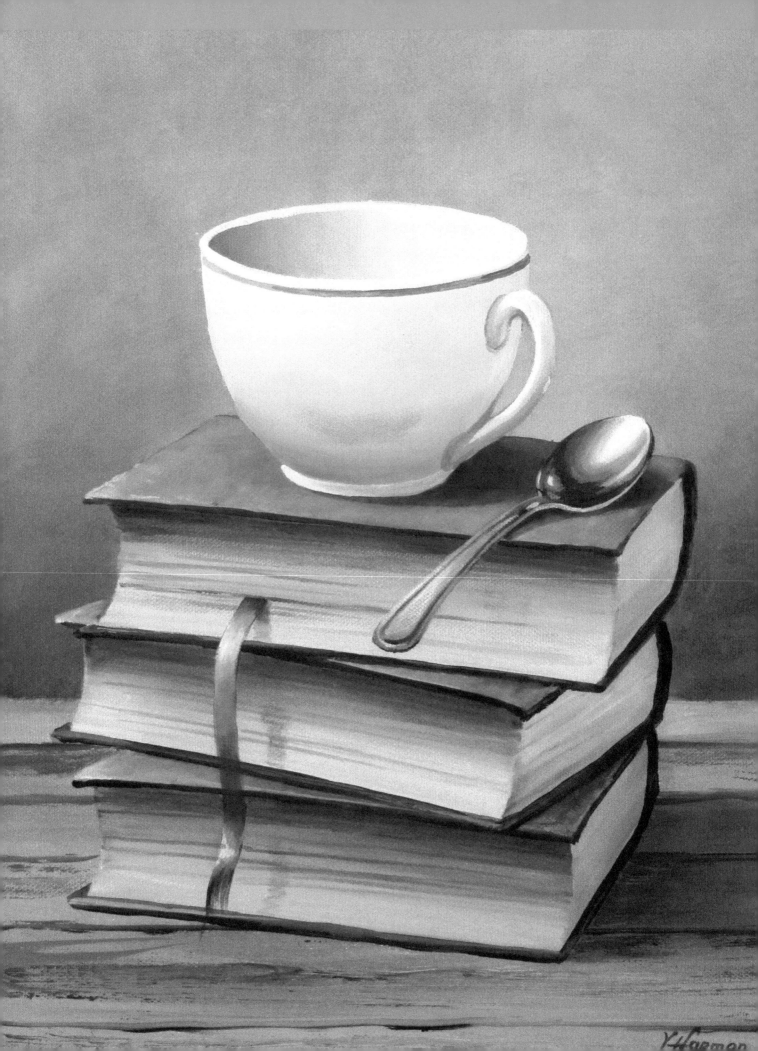

CHAPTER 2

Traditional Still Life

with Varvara Harmon

Explore the art of still life painting alongside accomplished artist Varvara Harmon. With her simple compositions and cheerful subject matter, Harmon teaches you how to bring each scene to life with lively color. Learn how to paint a charming floral scene, a tempting mound of macarons, and more as you hone your acrylic painting skills.

Macarons

The bright colors and buttery strokes of acrylic paint make it a perfect medium for representing these festive sweet treats. I choose to place the cookies in a neutral-colored environment to help them "pop" within the composition.

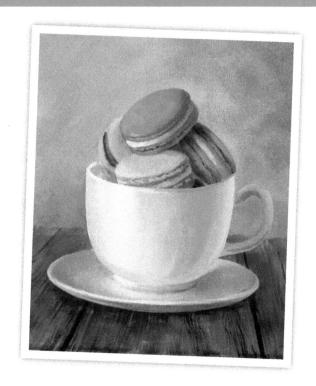

Color Palette

alizarin crimson • burnt sienna • cadmium yellow

cobalt blue • Hooker's green • Payne's gray

raw umber • titanium white

ultramarine blue • yellow ochre

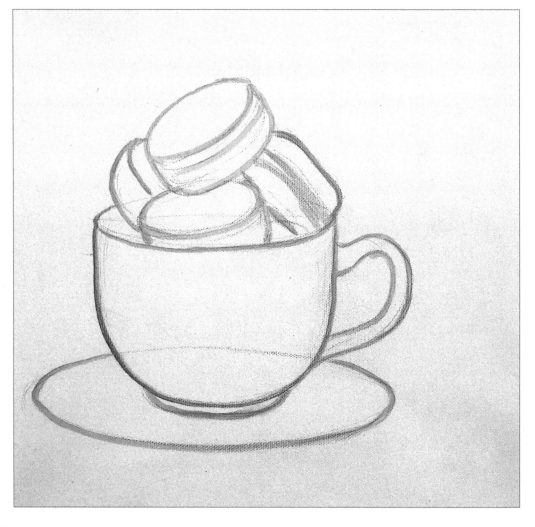

Step 1 I draw the composition with burnt sienna. You can do so with pencil or any paint color you wish.

Step 2 The primary colors I use to block in the wall and table are yellow ochre, burnt sienna, and raw umber. Notice that the table combination is a little darker than the wall. Also, as I paint the tabletop, I stroke in the direction of the boards and add slightly darker color below the saucer to create a shadow.

Step 3 To add texture to the wall and table, I use similar colors; however, I do not add water to the paint, keeping it thick. Using a 1" wide brush, I place random, crisscrossed strokes over the wall. For the table, I mix burnt sienna and ultramarine blue. Then, barely touching the canvas, I drag the brush in the direction of the wood grain. I also add darker lines to separate the individual table boards.

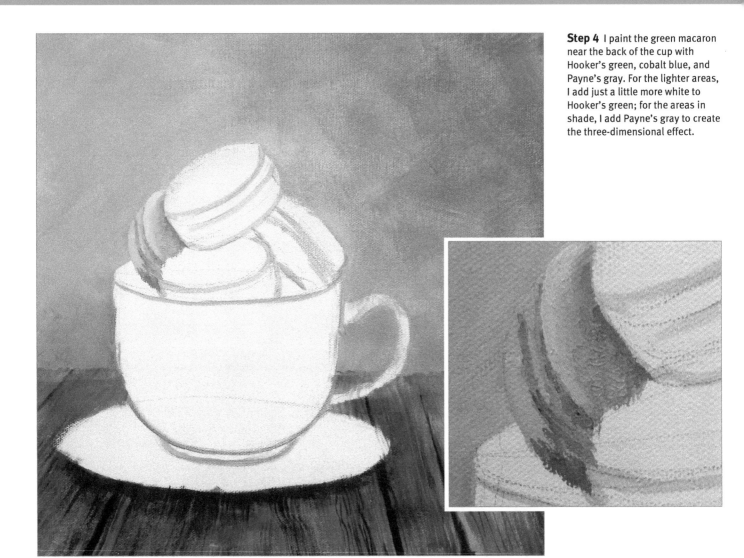

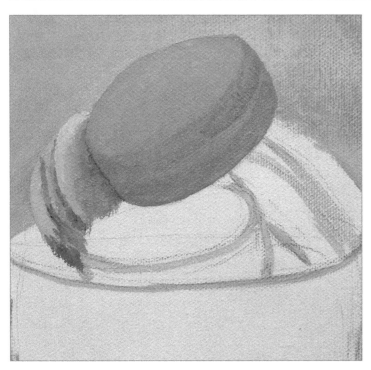

Step 4 I paint the green macaron near the back of the cup with Hooker's green, cobalt blue, and Payne's gray. For the lighter areas, I add just a little more white to Hooker's green; for the areas in shade, I add Payne's gray to create the three-dimensional effect.

Step 5 I mix alizarin crimson and cadmium yellow to create the base color of the two red macarons (top and right side).

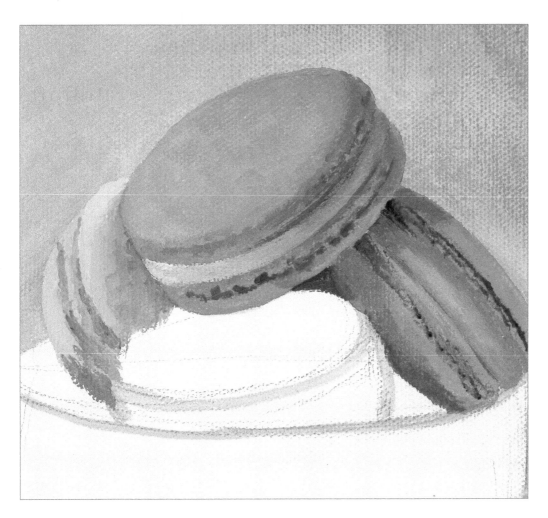

Step 6 To finish the red macarons, I add a little white to the mixture and paint the light areas. For the areas in shadow and the lines between the macaron layers, I use a mix of Payne's gray and alizarin crimson. For the middle section of the red macarons, I use white mixed with a bit of alizarin crimson and ultramarine blue.

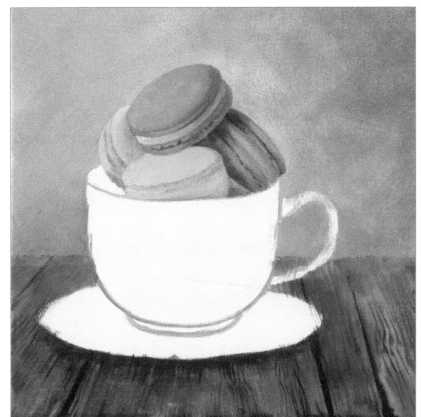

Step 7 I start painting the yellow macaron using a mixture of cadmium yellow and white. For light areas, I add a bit more white; for areas in shadow, I use pure cadmium yellow.

Step 8 To paint the white cup and saucer, I begin by mixing white and cobalt blue to create the base colors. I vary the values of this mixture to set the light and shadow areas of the cup and saucer.

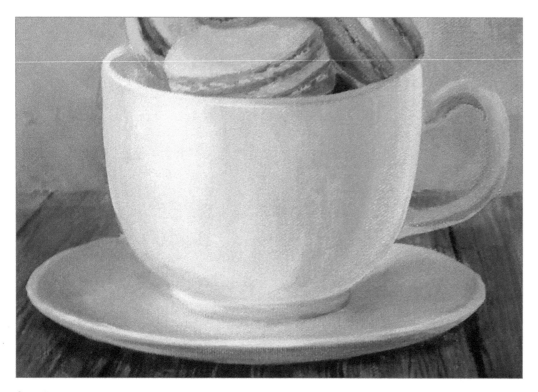

Step 9 I use a mixture of white and cadmium yellow to show light on the left side, and I emphasize the shadow with cobalt blue and a touch of alizarin crimson. Also, I show the reflection of the table's color on the bottom of the saucer using a mix of burnt sienna and white. As a final touch along the rim of the cup, I add reflections from the yellow and red macarons.

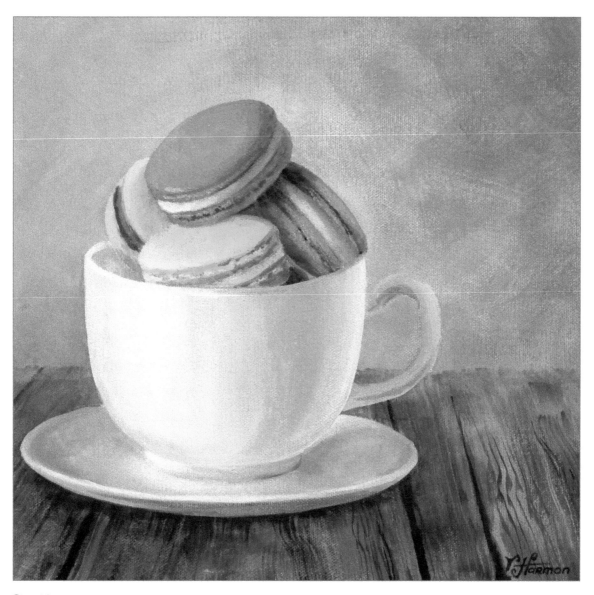

Step 10 To complete the painting, I address any final details and sign my name in the lower right corner.

Details

The wall and wood background elements add interest with subtle texture, but their neutral colors—browns, creams, and grays—keep them subdued against the playful colors of the cookies.

Oil Bottle & Jasmine

As you prepare your still life, remember that the viewpoint is an important aspect of the composition. The slightly elevated viewpoint of this setup—rather than a straight profile view—creates pleasing oval shapes within the bottle and enhances depth through receding lines of wood.

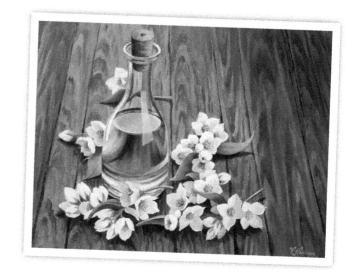

Color Palette

burnt sienna • burnt umber • cadmium yellow deep hue
cobalt blue • Hooker's green • Payne's gray • raw umber
titanium white • ultramarine blue • yellow ochre

Step 1 I use burnt umber to draw the composition onto the canvas. This step can also be done with pencil.

Step 2 To paint the table surface, I mix burnt umber, burnt sienna, and a bit of white. I paint the majority of the background table surface with burnt sienna, using burnt umber for the darker lines. Then I add white to the mix as I work on lighter areas of wood grain. Finally I use burnt umber to indicate the spaces between the boards.

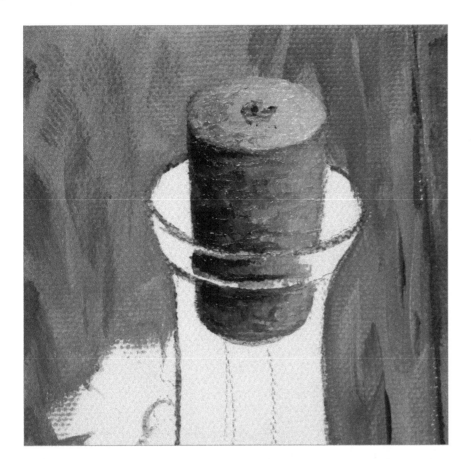

Step 3 To paint the cork in the bottle, I use yellow ochre, burnt sienna, and raw umber. I apply heavy strokes to suggest the texture of the cork. I apply yellow ochre along the right side of the cork, burnt sienna along the middle, and raw umber along the left. For the lighter cork top, I add a bit of white.

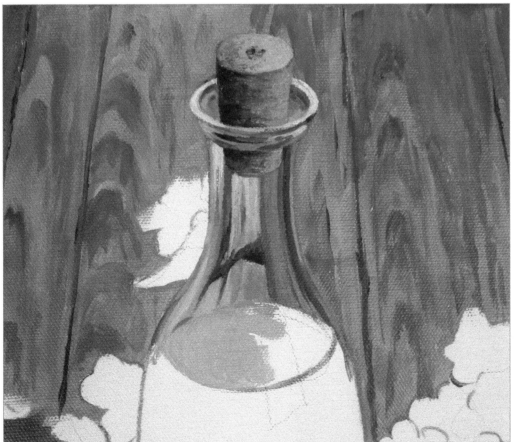

Step 4 I paint the upper (empty) portion of the bottle with cobalt blue and white, adding a bit of Hooker's green for leaf reflections. I also add burnt umber to show the color of the table through the glass, suggesting transparency and a reflective quality. To paint the surface of the oil, I use cobalt blue and white, which shows the reflection of the glass above, as well as a bit of cadmium yellow for the oil beneath.

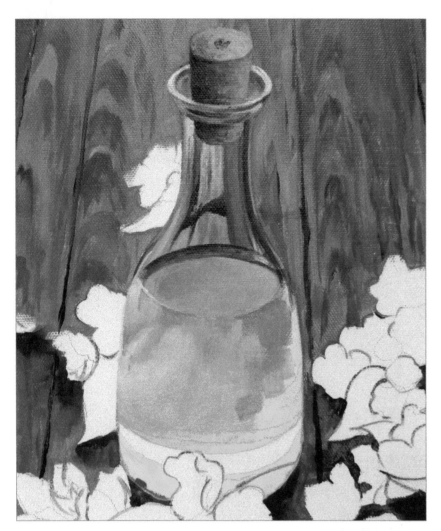

Step 5 To begin the portion of the bottle filled with oil, I use cadmium yellow deep hue and add Hooker's green to show the reflection of the flower leaves behind the bottle.

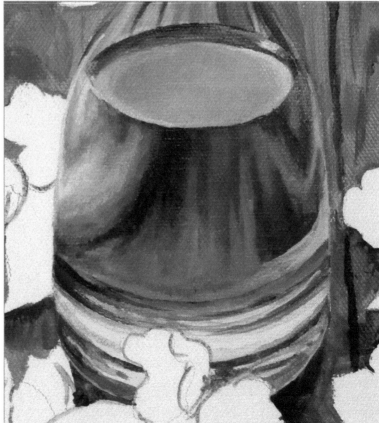

Step 6 Although light can pass through the glass and oil, we cannot see sharp details of the objects behind the bottle. However, we can see the brown of the table, the green of the leaves, and the white of the flowers. Because we see them through the yellow oil, I adjust all my colors accordingly. I paint the white flowers using the cadmium yellow deep hue. The leaves appear as a variety of greens, from dark (a mix of Hooker's green and raw umber) to light (a mixture of Hooker's green and cadmium yellow). I suggest variations of colors from the table using burnt sienna, raw umber, and cadmium yellow.

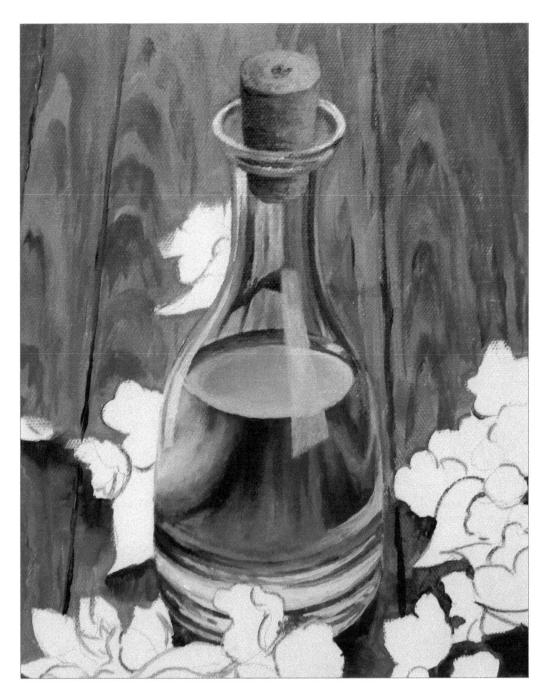

Step 7 To finish painting the bottle, I add reflections of light to the far left side and just a little to the right of the bottle's center. I do this using a mix of white and cobalt blue.

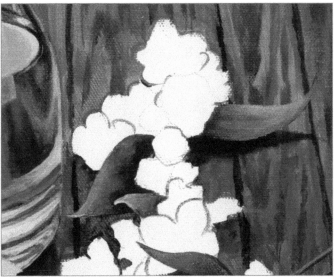

Step 8 When painting a cluster of flowers, I start by painting the leaves using Hooker's green as the primary color. Then I add raw umber for the shaded areas and cadmium yellow for the lighter parts of the leaves.

Step 9 For the flower petals, I combine cobalt blue, Payne's gray, and white to show the shaded areas of petals. Then I mix white with a bit of cadmium yellow to highlight the lighter parts of the petals.

Step 10 To finish painting the flowers, I use burnt sienna to paint the stamens in shadow, and I use cadmium yellow to paint the stamens in light.

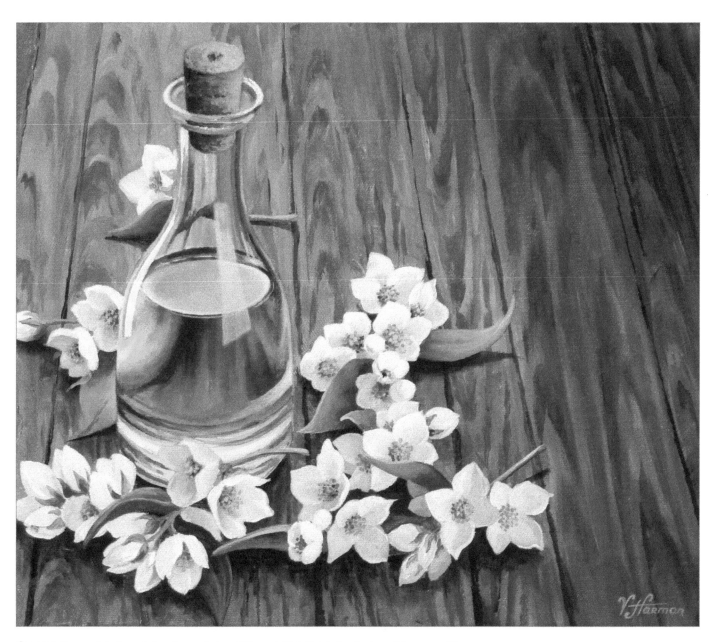

Step 11 To complete the painting, I repeat steps 8 through 10 to finish the clusters of flowers and leaves.

Artist's Tip

Make sure your brushes are completely clean of paint when you move on to a new step. It is very easy to create "muddy" colors on your canvas with a dirty brush.

Coffee Cup

In this painting, I use a palette of neutral colors to depict this tempting scene of coffee and sweets. Notice how the jam-filled pastry adds an effective "pop" of red color, which creates a pleasing triangular composition with the coffee cup and cream pot.

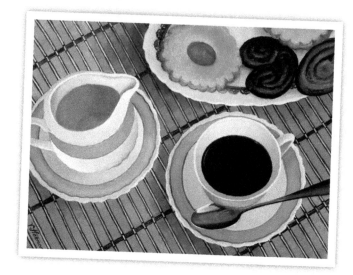

Color Palette

alizarin crimson • burnt sienna • burnt umber

cadmium yellow deep hue • cobalt blue

Payne's gray • raw umber • titanium white

ultramarine blue • yellow ochre

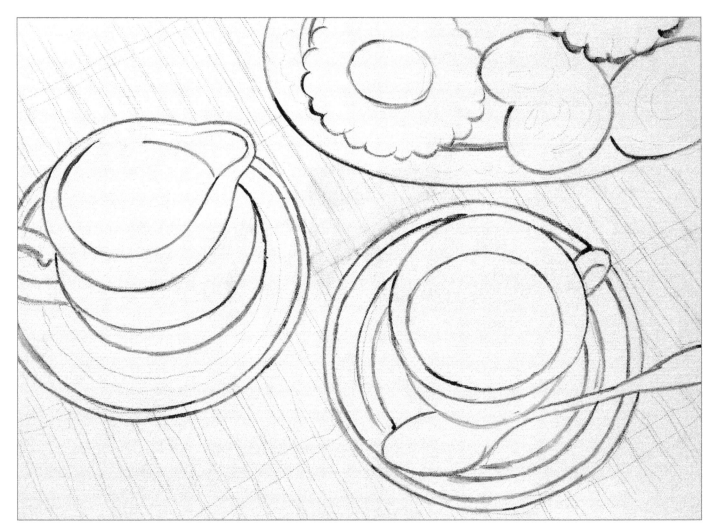

Step 1 I draw the main elements of the composition with pencil, followed by burnt umber to define the dishes and pastries. (You may choose to simply use pencil.)

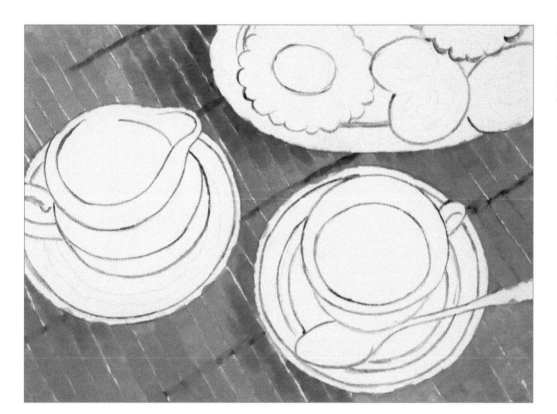

Step 2 I start painting the placemat with a mixture of yellow ochre and white, adding burnt umber and ultramarine to shade the areas to the right of the plate and saucers.

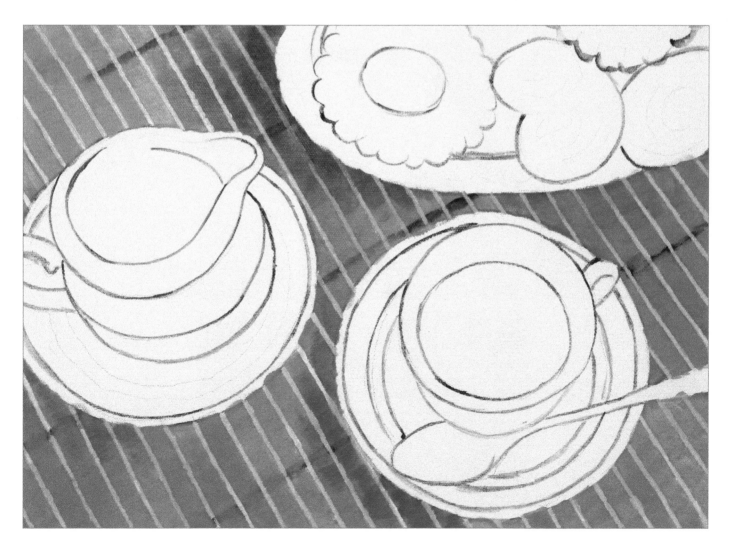

Step 3 Next I add the white lines between the wooden slats, using a steady hand and a liner brush.

Detail
For the areas of white in shadow, I tone down the lines by mixing Payne's gray and ultramarine into the white paint.

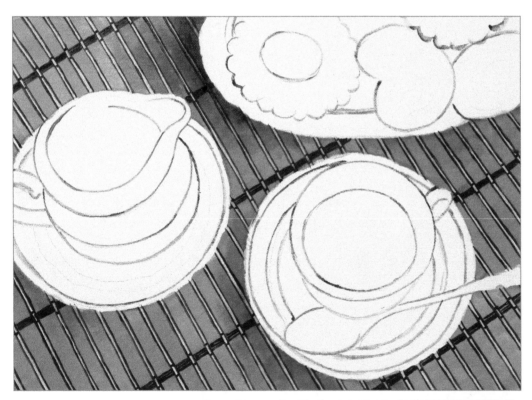

Step 4 To finish painting the placemat, I paint the dark spaces between the wooden slats and white design lines. I also add dark lines to represent the threads that hold the slats together, using a combination of burnt umber and ultramarine.

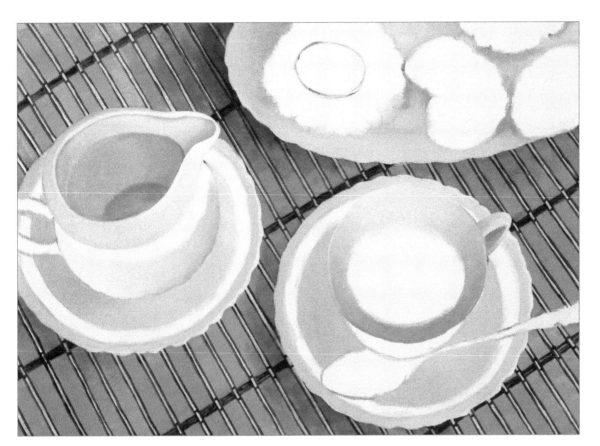

Step 5 I break down the process of painting the china into a few small steps. First, I paint the white parts of the cups, saucers, and plates using white as the primary color. I add a little yellow to the white in the light areas. To paint the areas in shadow, I add a little cobalt blue and Payne's gray to the white.

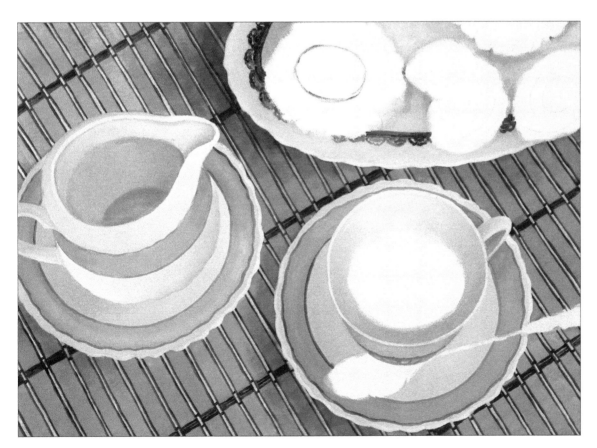

Step 6 In the next step, I mix variations of burnt sienna and white to paint the band design on the cups and saucers, showing the shapes of the china by placing lights and darks accordingly. Then, using cobalt blue, I place thin lines along both edges of the bands. Moving toward the areas in shadow, I add Payne's gray to darken the blue. If desired, you can add flowers or other designs, or you can keep it simple as shown. For the gold design on the cookie plate, I use burnt umber in areas of shadow and yellow to show reflections of light.

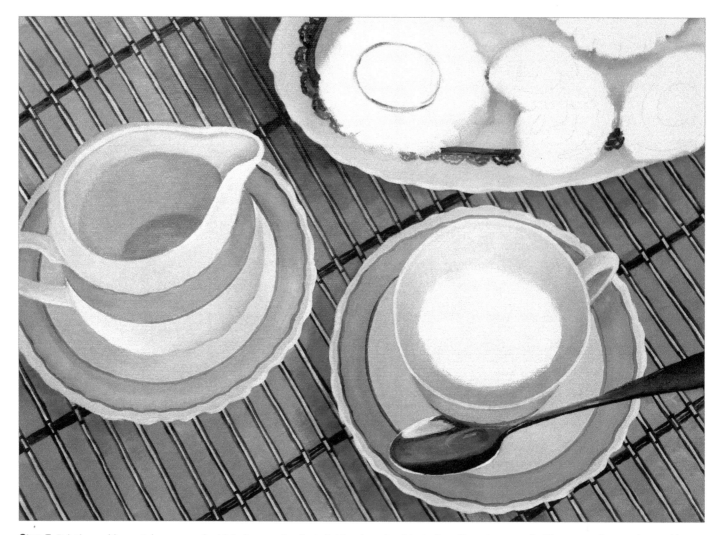

Step 7 Painting a shiny metal spoon can be tricky because it reflects light and nearby objects. I use Payne's gray and white as my primary color combination and then create many shades of gray, from nearly white to nearly black.

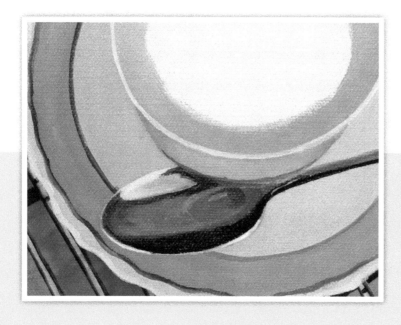

Detail

To show the cup's reflection in the spoon, I add the brownish colors that I used to paint the cup's band along with a bit of the same blue.

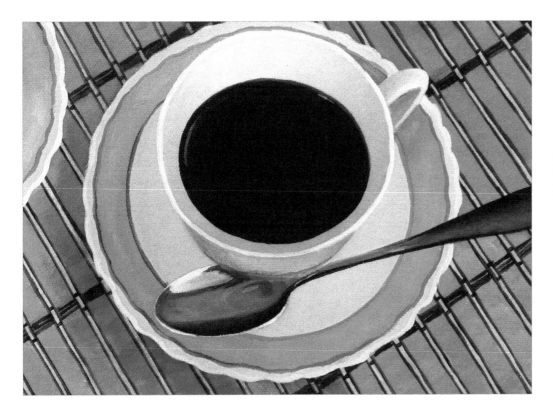

Step 8 Now I fill the cup with black coffee. I apply several layers of burnt umber to achieve a deep brown color; then I add reflections of light by adding a bit of white.

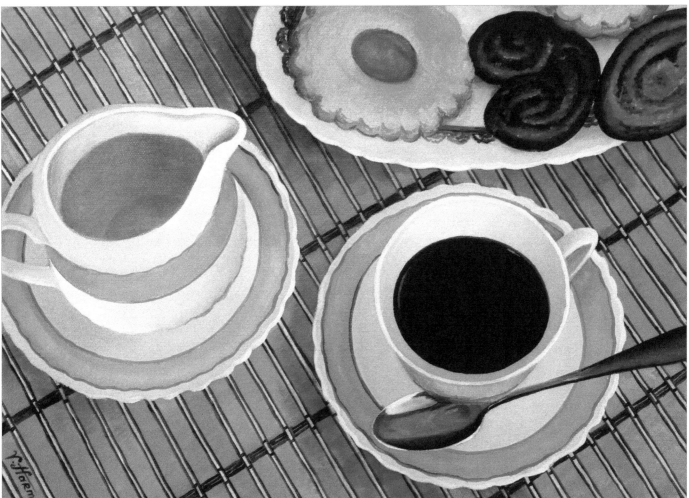

Step 9 I use raw sienna as the primary color for painting the jam-filled pastry. Next I add white to show the lightest areas and burnt umber for shadows. To paint the jam-filled center, I mix alizarin crimson, raw sienna, and white. I use similar colors to paint the remaining treats: burnt umber, raw sienna, and white. I use more burnt umber for the chocolate bun and more raw sienna for the plain cinnamon bun. As a finishing touch, I add a bit of white to highlight the swirls of the buns.

Red Zinnias

When designing a composition, it's always a good idea to consider the "rule of thirds." Imagine your canvas divided into thirds, both horizontally and vertically. The focal point of a composition should rest where two of the imaginary lines intersect, as demonstrated in this floral scene.

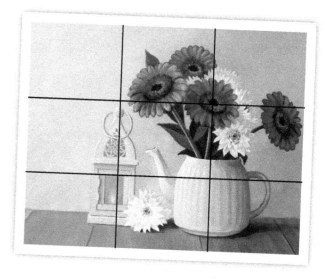

Per the "rule of thirds," the red zinnias serve effectively as the focal point near the upper-right intersection of lines.

Color Palette

alizarin crimson • burnt sienna • burnt umber

cadmium yellow deep hue • Hooker's green

Payne's gray • permanent blue • raw sienna • raw umber titanium white • ultramarine blue

Step 1 I draw the composition, which is the most important step for this piece. You can use a pencil or very fine lines of paint.

Step 2 To paint the wall on the left side, I use a mix of permanent blue and white. While working toward the right, I reduce the amount of white and add a bit of Payne's gray to darken the wall's value.

Step 3 To paint the table's surface, I mix burnt umber, burnt sienna, and a small amount of white. Lastly, I paint thin lines with pure burnt umber to indicate the spaces between the boards.

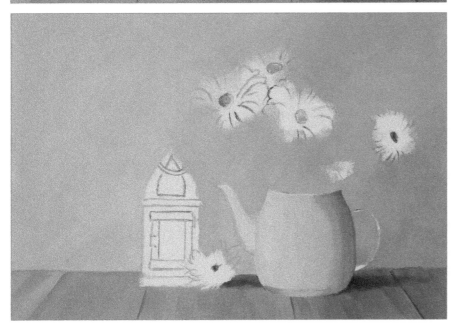

Step 4 For this step, I underpaint the teapot using white, ultramarine blue, and a bit of Payne's gray, establishing the overall values for a 3-D effect. (I will add details to the teapot in later steps.)

Step 5 I start the flowers by painting the leaves with Hooker's green, which acts as the primary color. Then I add raw umber and ultramarine blue for the shaded areas followed by cadmium yellow for the lighter parts of the leaves and sides of the stems.

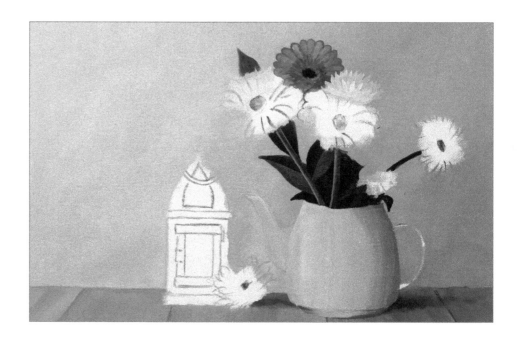

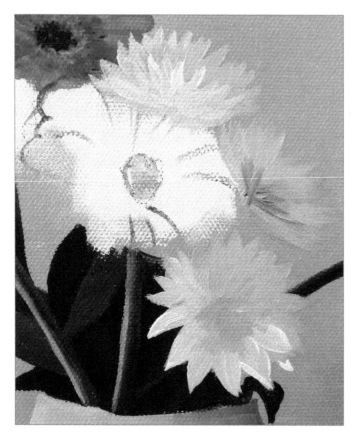

Step 6 I start painting the white zinnias using white mixed with cadmium yellow and Payne's gray. I add more yellow and gray to the mix for the darker parts of the flowers.

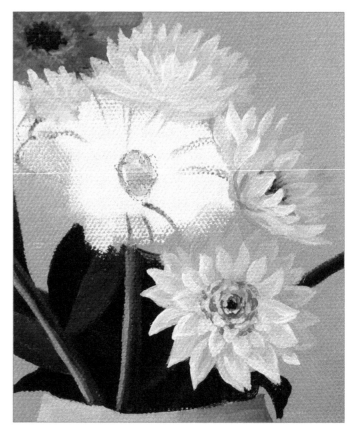

Step 7 To complete the white zinnias, I paint the center of each flower with burnt umber, and I touch up the petals in the light with a mixture of white and cadmium yellow.

Step 8 To finish the teapot, I add light reflections on the left side with white mixed with a small addition of cadmium yellow. I also emphasize the shadows in the vertical groves and other areas with ultramarine blue and Payne's gray.

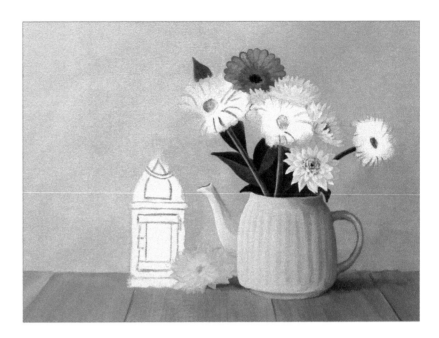

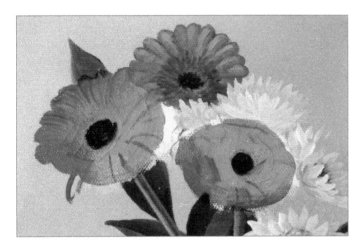

Step 9 Using alizarin crimson, I paint the circles to represent red zinnia petals. Also, I use Payne's gray for the centers of the flowers.

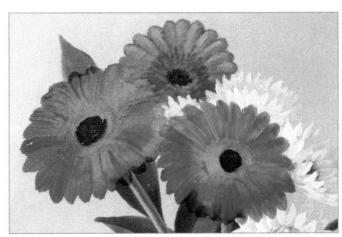

Step 10 I finish the outline of the flowers and place the petals with a ¼-inch round brush.

Step 11 Next I add white to the alizarin crimson and paint over the petals to show reflections of light.

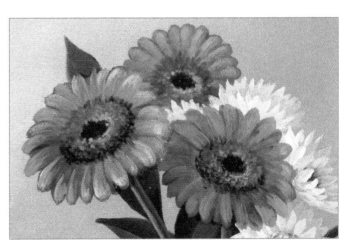

Step 12 To complete the flowers, I paint small petals in each center using a small round brush. I use a mixture of alizarin crimson and Payne's gray for the petals in shadow, followed by a mixture of alizarin crimson and white for petals in light. I leave the dark center of each flower untouched.

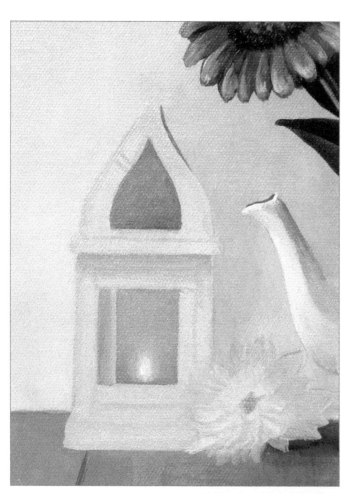

Step 13 I use a mixture of raw sienna and white to outline the lamp's shape. Then I add the darker section on top (where you can see the interior of the lamp) with a mixture of raw sienna and burnt umber. To show the wall through the lamp glass, I add a bit of Payne's gray to permanent blue. For the candlelight, I mix cadmium yellow with white, adding more white to the center of the flame.

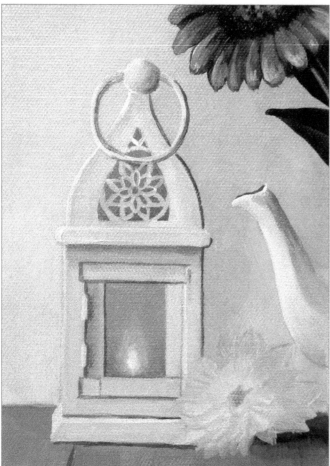

Step 14 To finish the design on the top part of the lamp, I use a mixture of raw sienna and white; then I add some darker details of the lamp with raw sienna and burnt umber, and I complete the details of the small ball and ring on top by using similar color combinations.

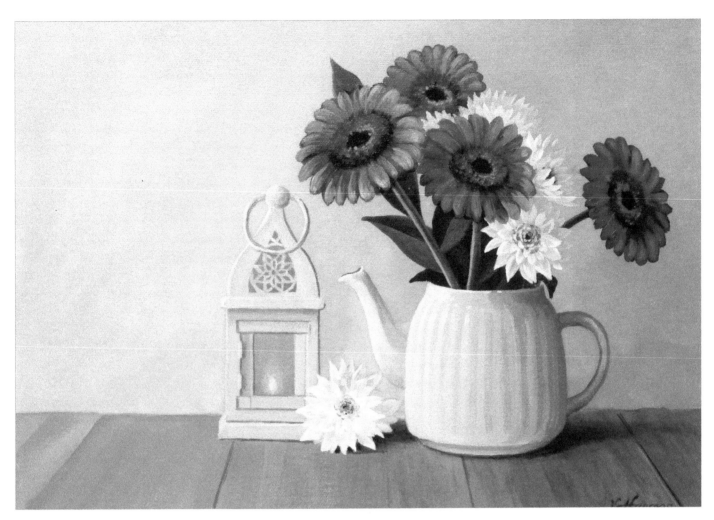

Step 15 In this final step, I paint the white zinnia between the teapot and candle lamp, following the steps and color palette used in Step 6.

Teapot Sequence

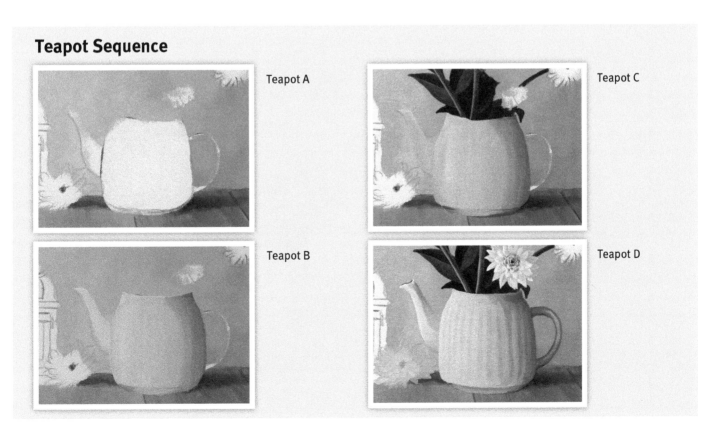

Teapot A

Teapot B

Teapot C

Teapot D

Teacup & Books

It makes sense that metal objects mirror their surroundings, but people are often surprised that white objects similarly reflect color—an effect that makes them very compelling. Because the background and objects that accompany the white focal point will influence its appearance, it's important to consider their color composition when planning your still life. The "white" china cup in this still life comes to life when warm yellow-browns pair with complementary cool blues.

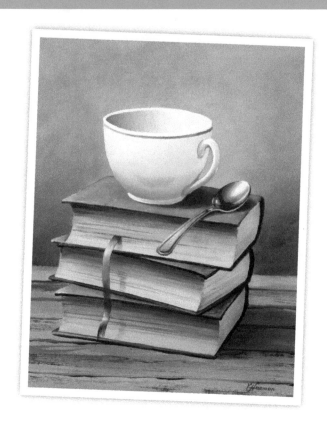

Color Palette

burnt sienna • Payne's gray • sap green • titanium
white ultramarine blue • yellow ochre

Step 1 On a 14" x 11" canvas, I work out my composition with a graphite pencil so I can make changes and corrections. When I'm happy with what I see, I outline the drawing with gray paint to keep my guide visible when I start applying color.

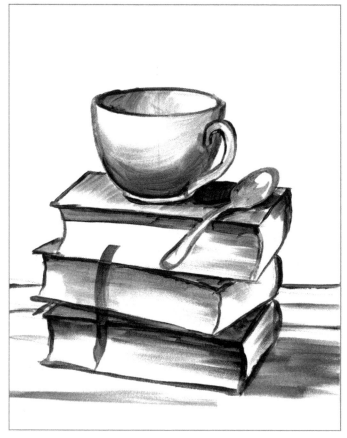

Step 2 I plan the balance of light and dark with a value sketch to avoid a washed-out painting. My focal point is a white cup, but that doesn't mean it's entirely light in value. I work out my shadows in thinned gray paint for a guide.

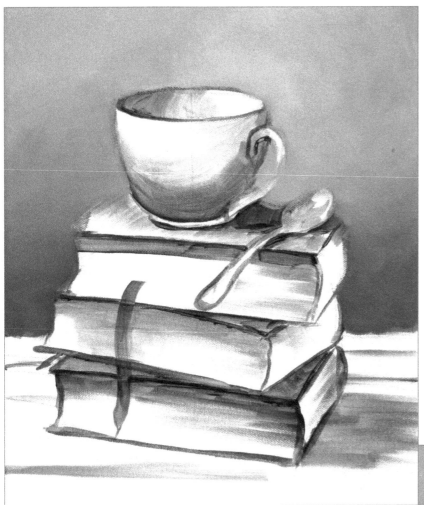

Step 3 I start with the back wall, which sets the tone of the painting, combining burnt sienna, yellow ochre, and ultramarine blue with a small amount of sap green. As I move into the shaded areas, I add more blue and green for a cooling effect.

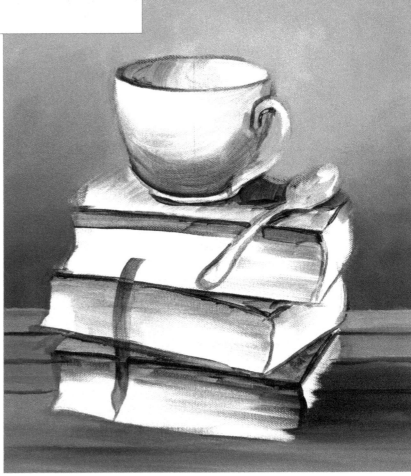

Step 4 I use similar colors on the table, but for a warmer palette, I mix in more yellow ochre and less blue and green. For the shadow beside the books, I add more blue. I paint lines between the boards using burnt sienna mixed with ultramarine blue.

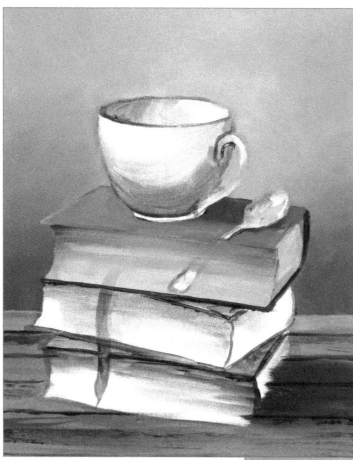

Step 5 For a wood-grain effect, I load a ½" brush with a mix of burnt sienna and ultramarine blue before lightly dragging it across the table. I combine burnt sienna, yellow ochre, and ultramarine blue for the book pages, adding gray for contrasting shadows. The cover is ultramarine blue mixed with titanium white, sap green, and Payne's gray.

Step 6 I painted the top book to set the ground for my cup, but I'll establish the focal point before attending to the others. Mindful of the light source on the left, I reserve pure white for the directly lit portions of the cup on the outer left and inner right. I mix the shadows inside the cup with titanium white and the background's brown. I paint the shadows on the outside with titanium white and the book's blue.

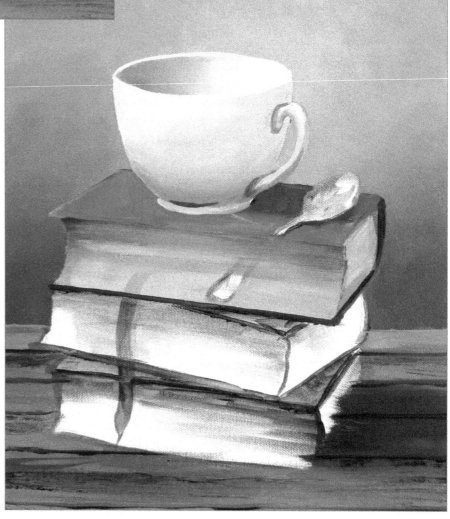

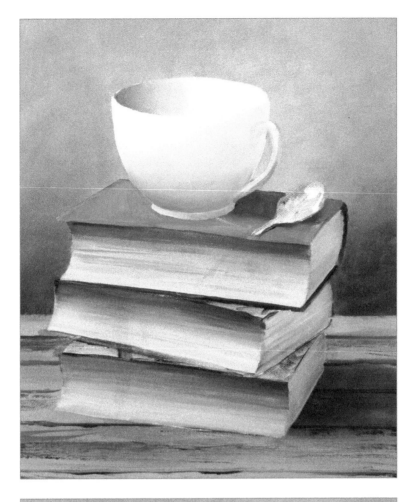

Step 7 I continue layering on the cup until I've covered the value sketch shadow on the handle and lower portion of the bowl. Then I turn my attention back to the books, layering the same mix from step 5 over all the pages and then adding shadows—including the deep one under the top cover—by mixing in gray.

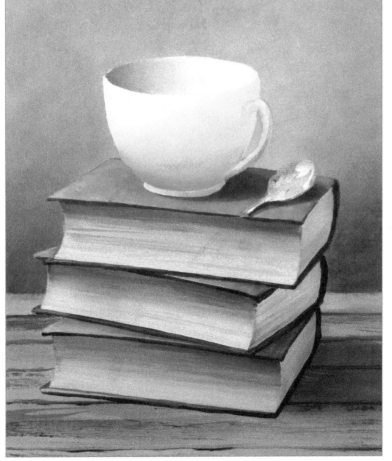

Step 8 With the pages firmly established, I turn my attention to the remaining book covers, applying the same mixture of ultramarine blue, titanium white, sap green, and Payne's gray. In addition to painting the lower book covers, I once again layer over the top cover, mixing in more gray where the cup casts a shadow.

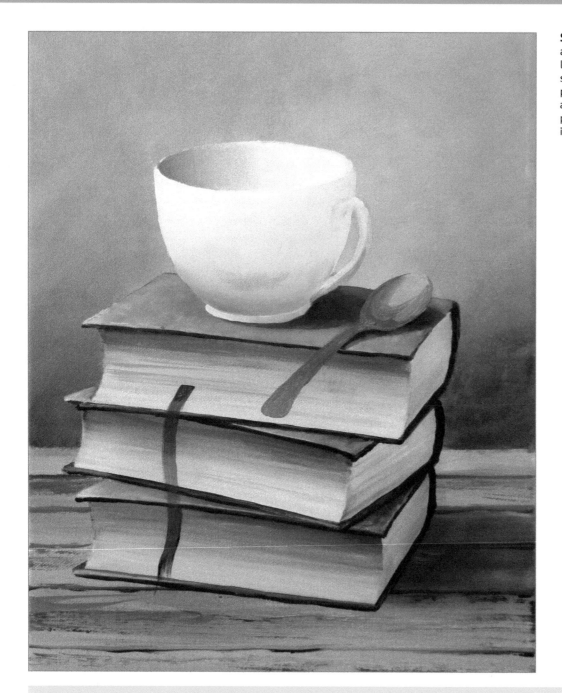

Step 9 Now it's time to turn my attention to the details in this still life setting: the bookmark and spoon. I place the bookmark using pure ultramarine blue; I will worry about refinement later. I start painting the spoon by re-creating its form with a medium gray tone.

Detail

To give the bookmark a silky appearance, I mix white into the blue for highlights, adding gray for shadows. On the spoon, I mix Payne's gray with burnt sienna for a dark metal base. Then I touch in reflections, mixing white with both blues.

Bookmark A

Bookmark B

Spoon A

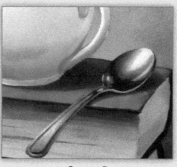

Spoon B

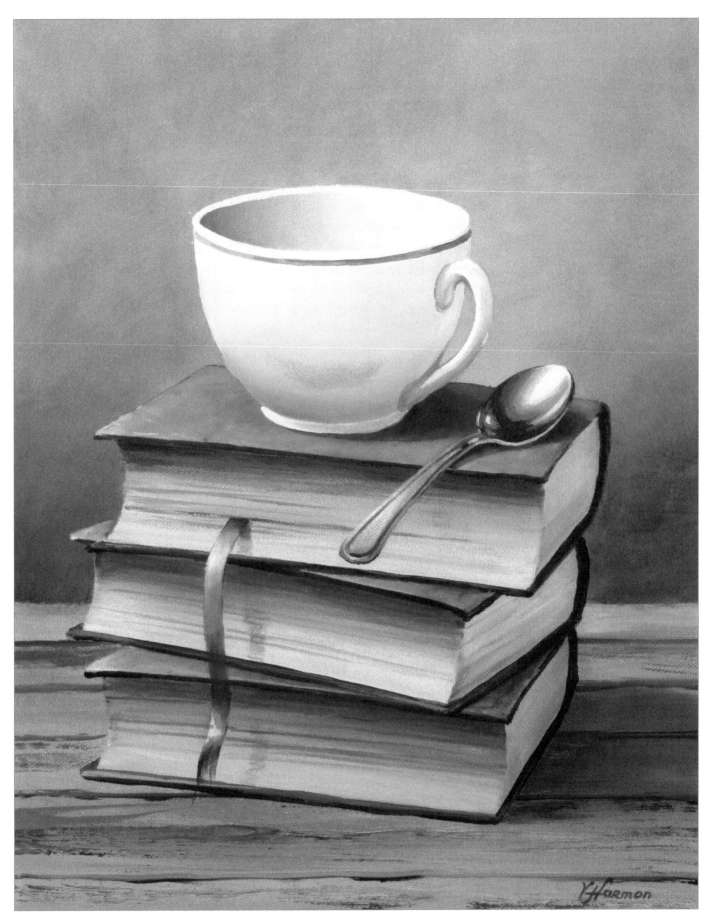

Step 10 The finishing touches are the refining details. In addition to completing the spoon and bookmark (see "Detail" on page 46), I spend a little more time on the cup. I re-establish the shadows on the handle and touch up the reflections on the bottom of the cup, in both cases mixing a bit of ultramarine blue with white. With a slightly darker mix, I also paint the line around the rim of the china.

Pottery

The reflections on smooth, shiny objects hold a strong visual appeal, but so do the natural variations and inconsistencies of textured objects. Including multiple objects with varying textures produces an even greater level of interest, thanks to the contrast, as shown in this example of vintage pots against a cracked wall with exposed brick.

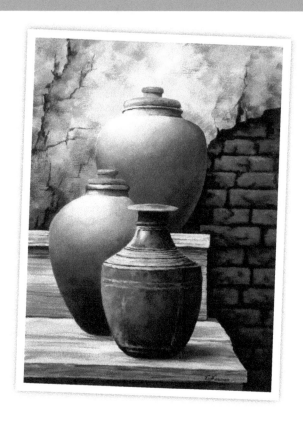

Color Palette
alizarin crimson • burnt sienna • Payne's gray • sap green • titanium white • ultramarine blue yellow ochre

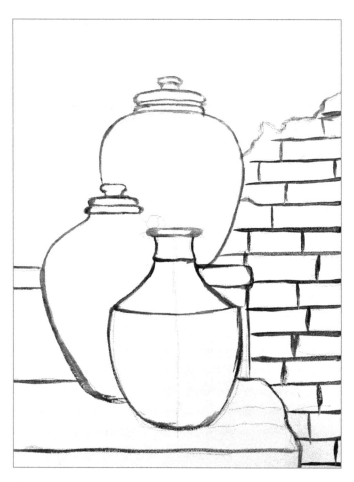

Step 1 When I sketch the basic shapes on my 12" x 16" canvas (first with pencil, then with gray paint), I also take the time to determine the parts of my composition that matter most, establishing where I'll be focusing my attention to detail.

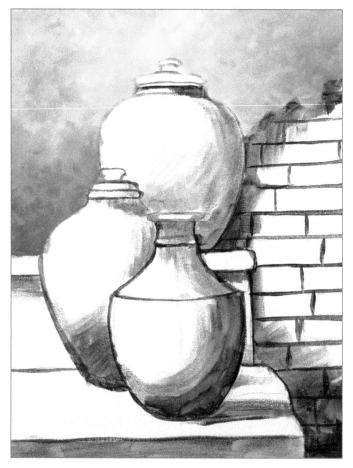

Step 2 After washing in shadow placement with a thin layer of Payne's gray, I turn my attention to the wall. For the first layer, I combine yellow ochre, burnt sienna, ultramarine blue, and titanium white. Next, to age the wall, I somewhat randomly and unevenly touch in a variety of colors from my palette.

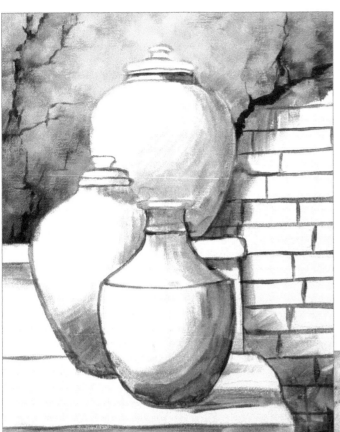

Step 3 To make the wall more interesting, I add a rough texture to its surface. I use the same random, uneven selection of colors from step 2, this time drybrushing the paint onto the canvas. I also paint in deep cracks, using a mix of burnt sienna and ultramarine blue.

Step 4 For the bricks, I begin with a burgundy underpainting. I apply a mixture of burnt sienna and ultramarine blue, using more blue in the shadows. The underpainting will speed up painting by establishing the value and direction of subsequent layers.

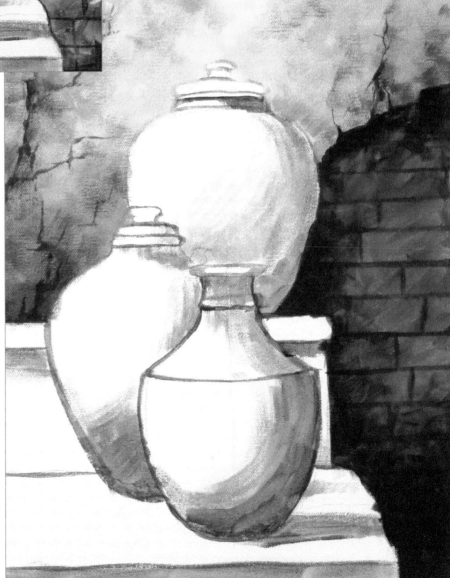

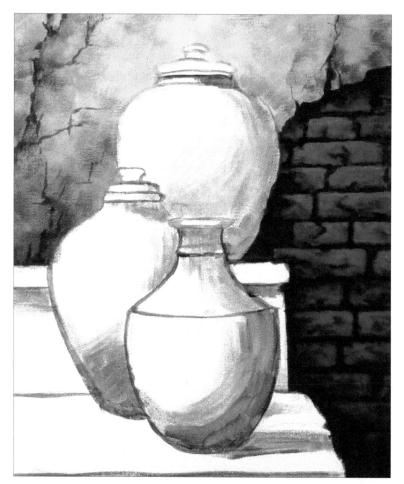

Step 5 My initial sketch will help me immensely here, because I paint each brick individually. Although I use a base mix of burnt sienna and ultramarine blue, this building is so old that the bricks are uneven in shape, size, and color, so I also create variations with alizarin crimson, yellow ochre, and titanium white.

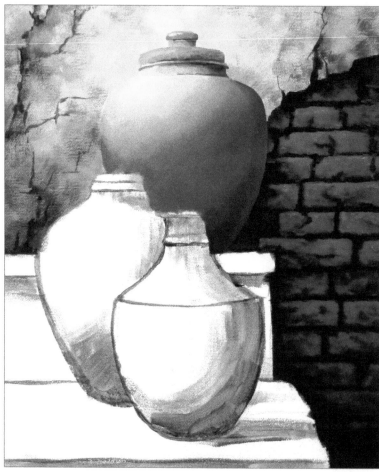

Step 6 For the top pot, I mix varying proportions of ultramarine blue, yellow ochre, burnt sienna, Payne's gray, and titanium white, laying down a loose underpainting before layering on value transitions. For lighter values, I include more yellow and white in the mix, colors that gradually decrease as the blue and gray increase in the shadows.

Step 7 I don't want to accidentally paint over the pot edges after they're finished, so I take a moment to focus on the shelves. As with the wall, I use a mix of yellow ochre, burnt sienna, ultramarine blue, and titanium white; however, I use more blue and white for a lighter, grayer tone, with even more blue in the shadows.

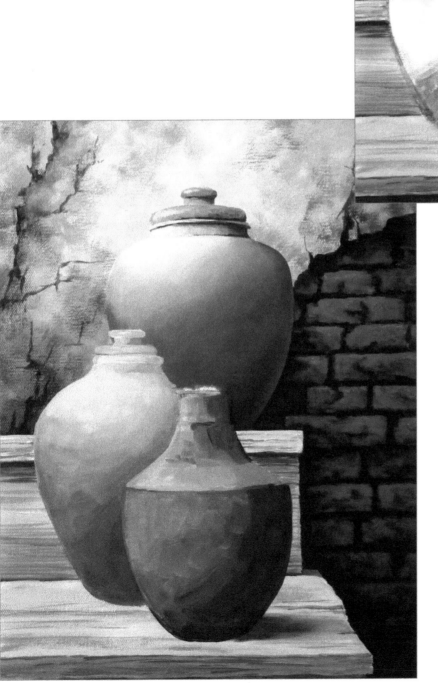

Step 8 The two foremost pots have similar color bases. I underlay a combination of ultramarine blue, yellow ochre, burnt sienna, Payne's gray, and titanium white for both, adding a little alizarin crimson to the middle pot for its clay color. For the oxidized areas of the copper pot, I also mix in sap green. As with the first pot, these underlayers include light to dark transitions with slight variations in the color mix proportions.

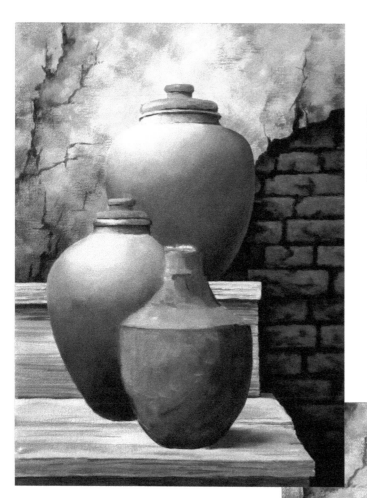

Step 9 I like working from the background forward, even when it comes to detail. So my next move is to refine the clay pot in the middle, painting its cover with a base of yellow ochre and adding in minor portions of burnt sienna and ultramarine blue.

Step 10 Turning my attention to the copper pot's development, I mix ultramarine blue and burnt sienna for a layering base; then I add a bit of titanium white for the lighter areas. In the oxidized portions, I mix sap green, yellow ochre, ultramarine blue, and white.

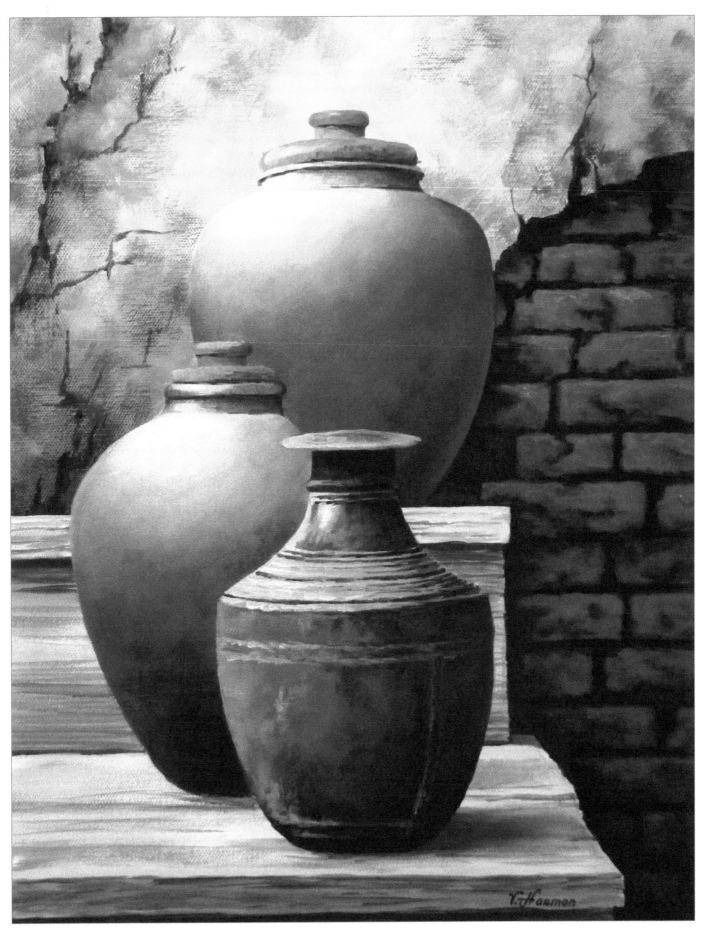

Step 11 To give the copper pot more character, I add a patina-laced surface detail. Working with the same mix as in step 10, I vary the color proportions to distinguish light from shadow. I also add a rougher texture to the shelf for greater contrast.

Light, Shadow & Color

with Janice Robertson

This chapter celebrates the simple elegance of home. Janice Robertson shares her painterly style and exquisite treatment of light, shadow, and reflections in a variety of still life compositions. From flowers to teapots to cherry tomatoes, any artist can appreciate and be inspired by Robertson's ability to find the beauty in familiar, everyday settings.

Bottles

Colored glass offers a great opportunity to practice painting colorful light, reflections, and shadows. The bottles in this project may appear complex, but you can easily build them using base colors followed by darks, lights, and highlights. As you look at your reference, focus on seeing the values as simple shapes.

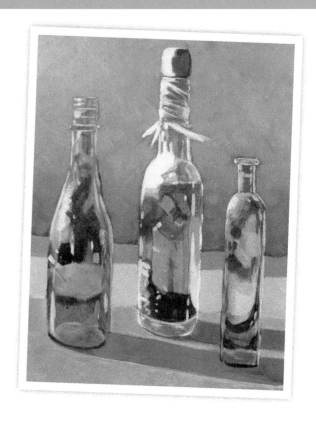

Color Palette

quinacridone red • Hansa yellow medium • phthalo blue
dioxazine purple • titanium white

Medium: Acrylic glazing liquid (slow drying)

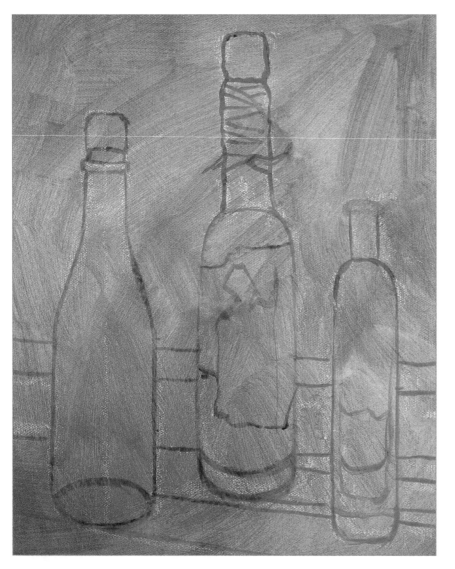

Step 1 To begin, I apply a thinned layer of quinacridone red over an 11" x 14" primed canvas. Once dry, I draw the basic shapes of the composition with white chalk. Then, when I am happy with the drawing, I use dioxazine purple and a ¼" flat brush to go over the chalk lines.

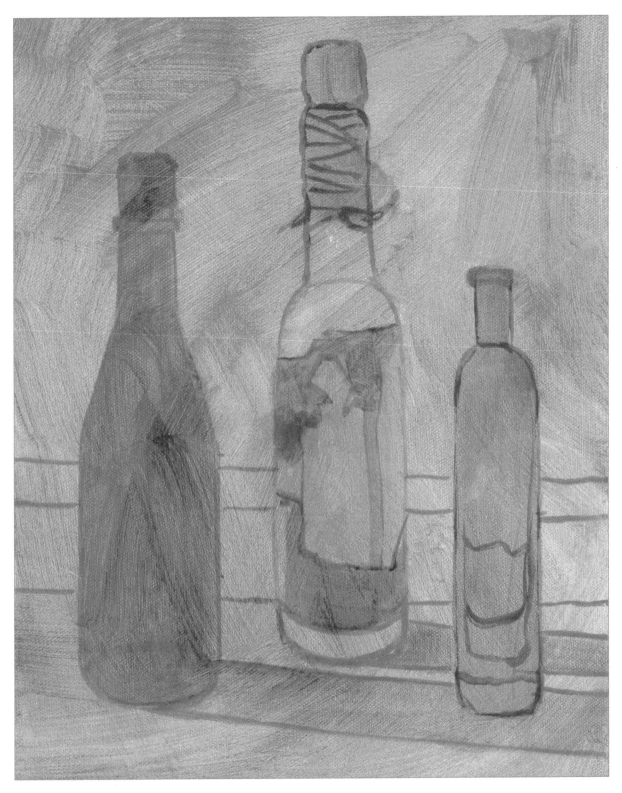

Step 2 I block in the base colors of the bottles, thinning the colors with a damp brush and glazing fluid. For the blue bottle, I use phthalo blue; for the red bottle, I use quinacridone red and dioxazine purple. I use Hansa yellow for the yellow bottle. To add shadows, I apply thinned phthalo blue in long strokes.

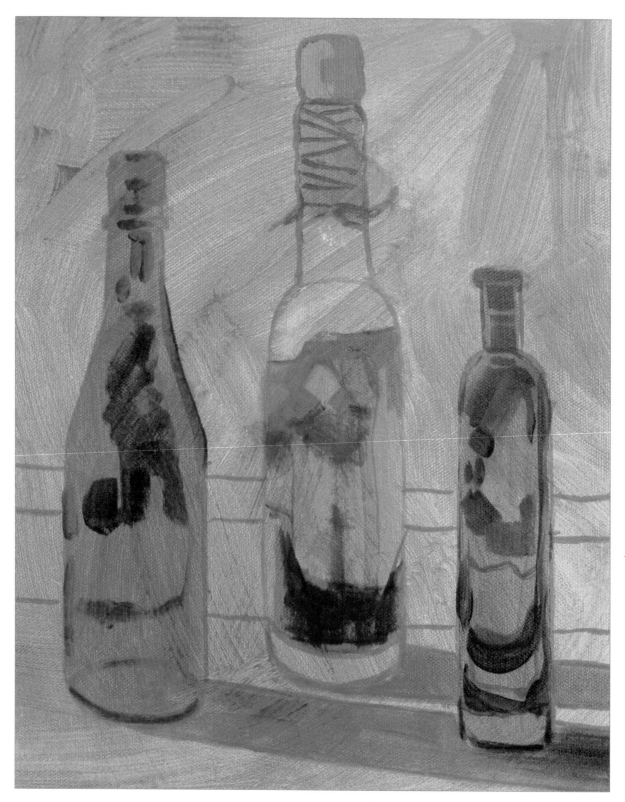

Step 3 In this step, I focus on adding the darks. For the blue bottle, I use phthalo blue and quinacridone red. I switch to dioxazine purple and Hansa yellow to create the darks in the red and yellow bottles. I use the same colors to develop a cast shadow for each bottle.

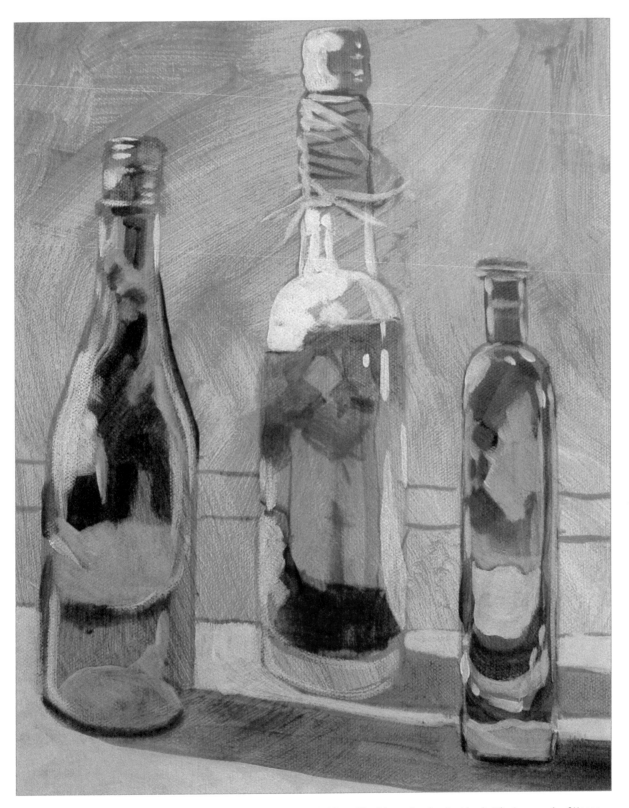

Step 4 Now I add the lighter areas of the bottles. I mix a little phthalo blue with white to develop the blue bottle. I use a mix of Hansa yellow and white for the yellow bottle, and I switch to white and thinned quinacridone for the red bottle. To create the tabletop, I apply a light blue mix of phthalo blue, quinacridone red, and white.

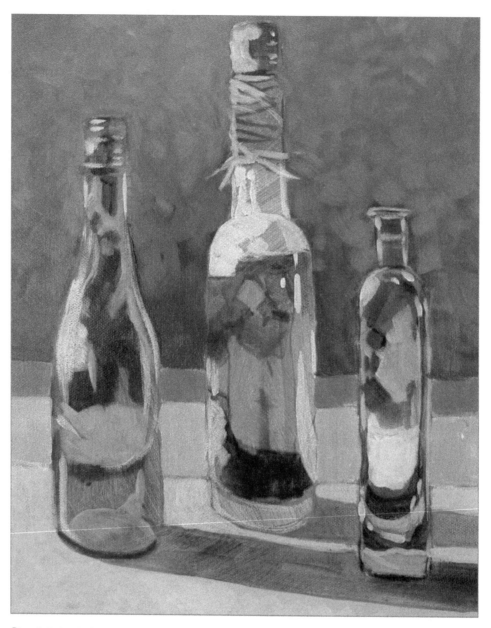

Step 5 To begin the background, I create a pale gray using white, a bit of phthalo blue, quinacridone red, and Hansa yellow. I add this to the strip of light behind the bottom half of the bottles. I use less white for the darker strip above. Then I loosely apply a range of grays to the rest of the background above the strip, working in more white as I move toward the top.

Detail

Keep your background strokes loose and painterly, which will keep the viewer focused on the crisp lines of the contrasting tones of the bottles.

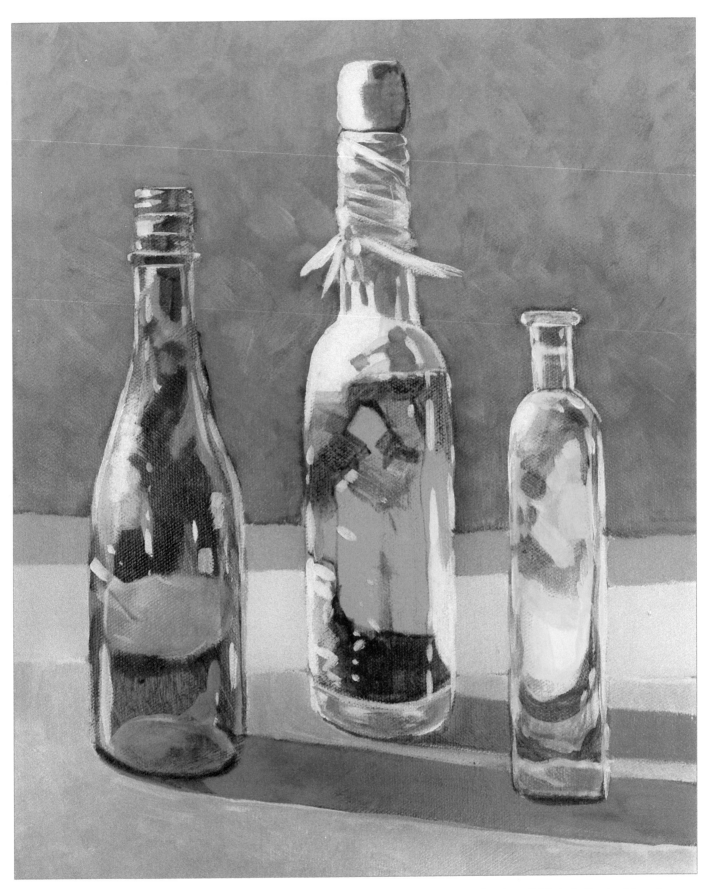

Step 6 To finish, I apply a second coat over the background, cooling it by working more phthalo blue into the mix. To finish the bottles, I paint small areas of light with white followed by thin glazes of quinacridone red, Hansa yellow, and phthalo blue.

Cherry Tomatoes

An imperfect scene often results in a more dynamic piece. For this setup, a few tomatoes spilled outside of the bowl and a few wrinkles in the cloth create interesting shadows and balance the composition.

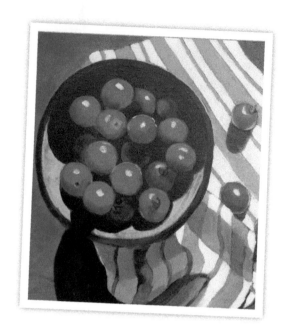

Color Palette

dioxazine purple • Hansa yellow medium • phthalo blue pyrrole red • quinacridone gold • titanium white

Medium: acrylic glazing liquid (slow drying)

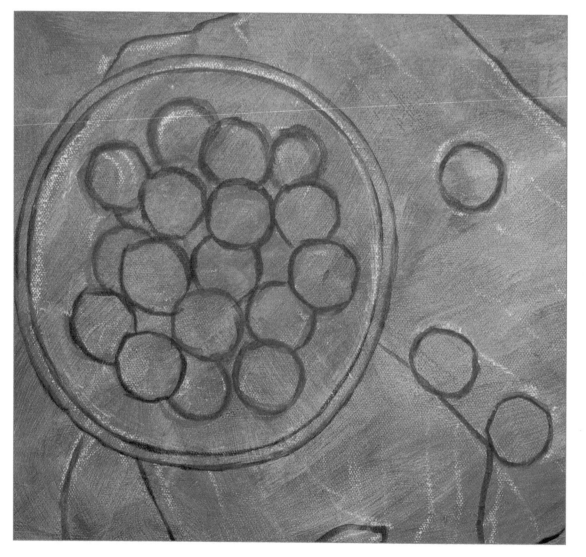

Step 1 I apply an underpainting of thinned quinacridone gold over a 12" x 12" primed canvas. Then I use dioxazine purple to draw the basic shapes of the composition.

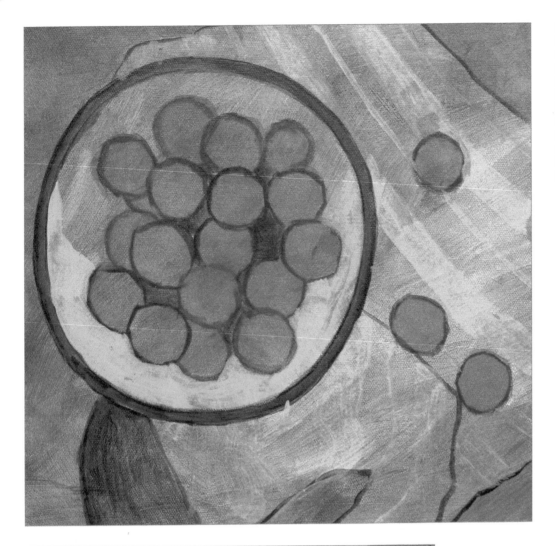

Step 2 Next, I block in the tomatoes with pyrrole red. To paint the rim of the bowl, I use quinacridone gold and dioxazine purple. For the inside of the bowl, I use a bright turquoise mix of white, phthalo blue, and a bit of Hansa yellow. I use a slightly greener version of this mix to begin the stripes on the cloth. For the areas of shadow in the composition, I apply dioxazine purple.

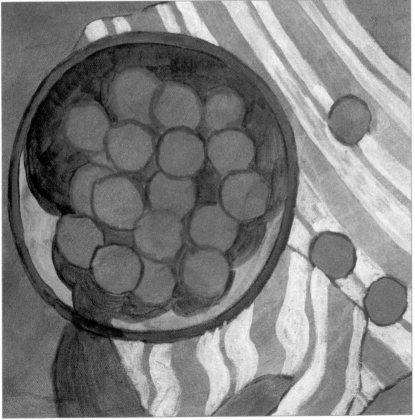

Step 3 Now I use white to paint more stripes on the cloth. I use phthalo blue and pyrrole red to represent the shadows in and under the bowl.

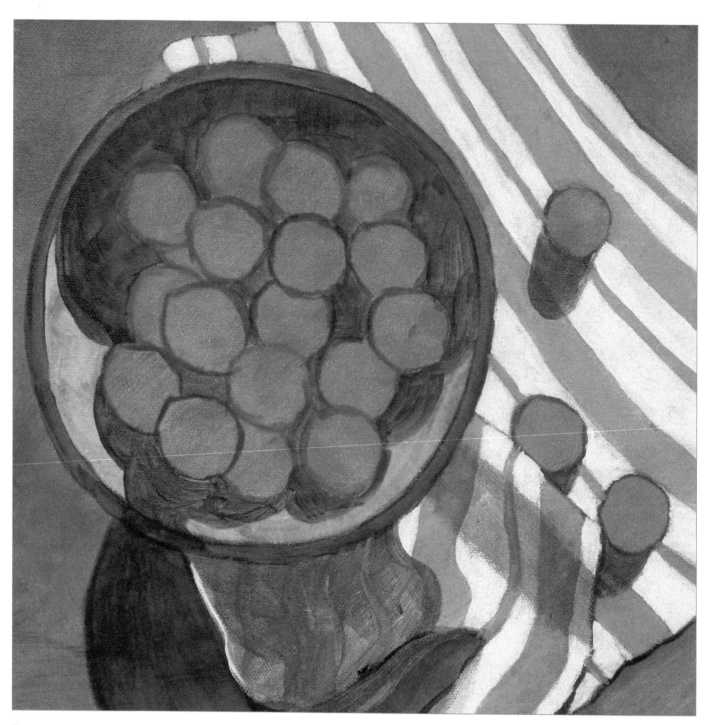

Step 4 In this step, I paint the shadows in the bowl again, this time using dioxazine purple and quinacridone gold for warmth. To create the rim of the bowl, I use quinacridone gold, dioxazine purple, and a little phthalo blue. I use quinacridone gold, pyrrole red, dioxazine purple, and white to develop the shadows in the cloth.

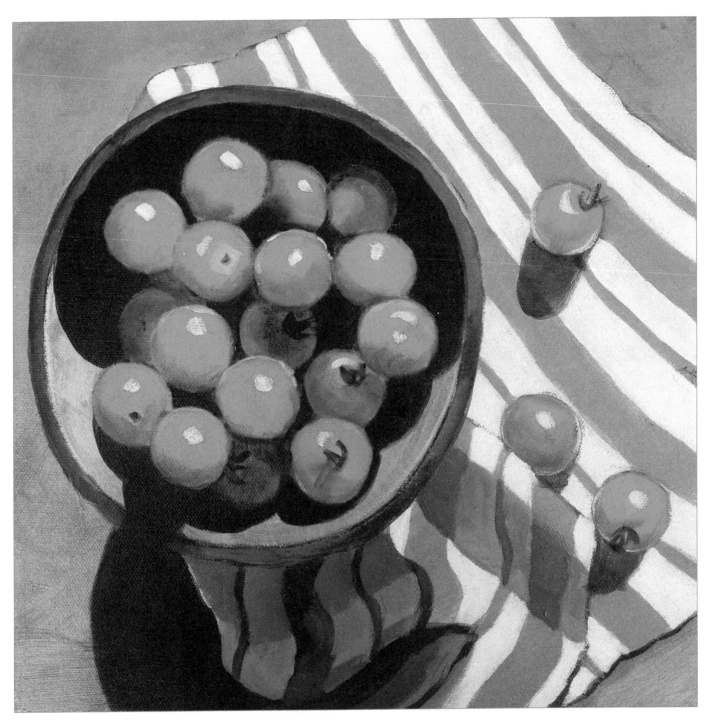

Step 5 Now I focus on painting the tomatoes. I begin by glazing the darkest tomatoes with purple. Then I use pyrrole red for the middle values and a combination of Hansa yellow medium, white, and pyrrole red for the lighter areas. To emphasize the darks, I add dioxazine purple to the pyrrole red. Next, I paint a final layer of shadows in the cloth using white, quinacrione gold, phthalo blue, and pyrrole red. To finish, I paint a second layer of white on the stripes and add white highlights on the tomatoes.

Roses

In this painting, I begin by toning the canvas with a vibrant layer of color. This bright pink peeks through and influences subsequent layers of paint, creating warm, luminous effects in the finished piece.

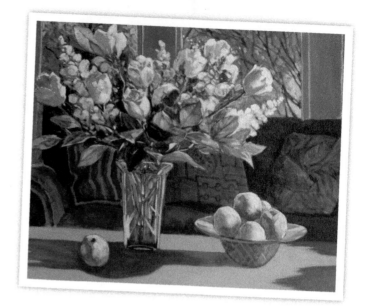

Color Palette

dioxazine purple • green gold • Hansa yellow medium
quinacridone gold • quinacridone red
titanium white • ultramarine blue

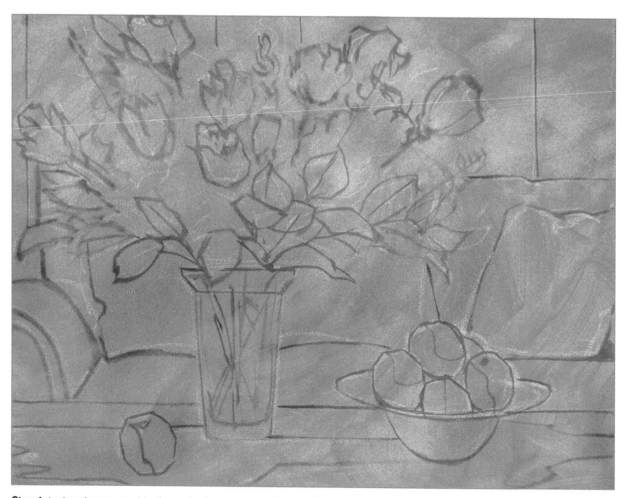

Step 1 I prime the canvas with a layer of quinacridone red thinned with water. Once dry, I draw the basic shapes of the composition with chalk and go over the lines with dioxazine purple.

Step 2 I paint the first layer of the sofa with quinacridone gold and dioxazine purple, mixed with a little glazing fluid. For the dark green leaves, I use quinacridone gold and ultramarine blue. For the lighter leaves, I use green gold and white. I don't worry about details at this point; my goal is to get the basic shapes and colors in place.

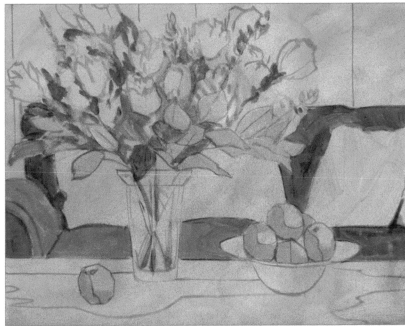

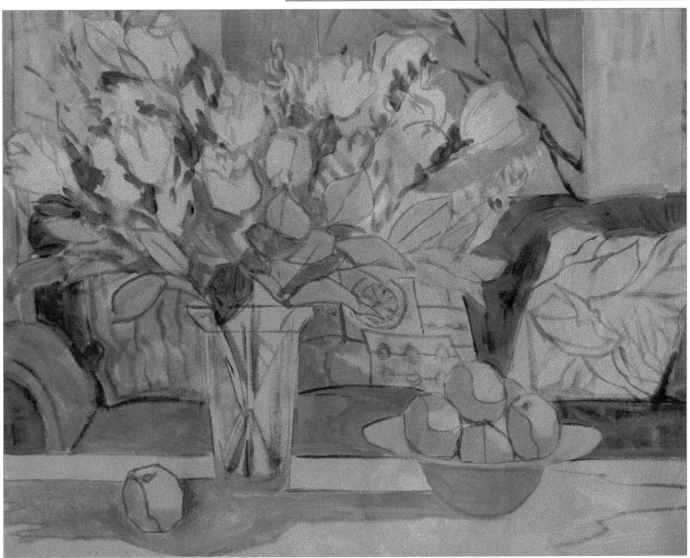

Step 3 Now I begin the background. Using ultramarine blue, white, and a small amount of green gold, I paint the area through the window. I add the background branches and the patterns on the pillows with quinacridone gold and dioxazine purple. The shadows on the table are painted with dioxazine purple, ultramarine blue, and white. The top of the bowl is ultramarine blue and white, and the bottom of the bowl is ultramarine blue. For the window frame, I use white mixed with a little quinacridone red, ultramarine blue, and quinacridone gold.

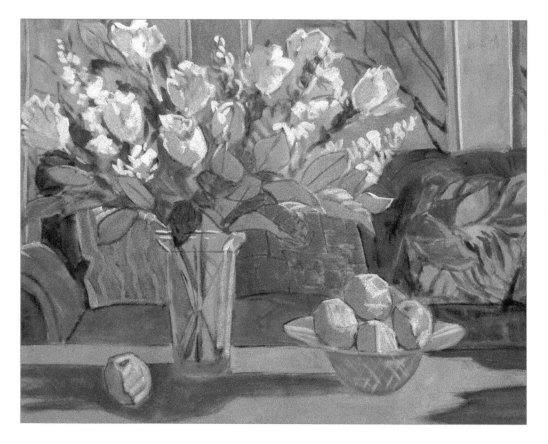

Step 4 Next I apply a layer of white over all the highlights of the flowers, apples, and vase. I paint the patterns on the pillows with mixes of Hansa yellow, quinacridone red, ultramarine blue, dioxazine purple, and white. For the tabletop, I use quinacridone gold and white. I apply another layer over the table shadow with dioxazine purple tinted with a bit of white. I use glazing fluid in the mixes throughout the painting, which helps my paint flow and stay wet a little longer.

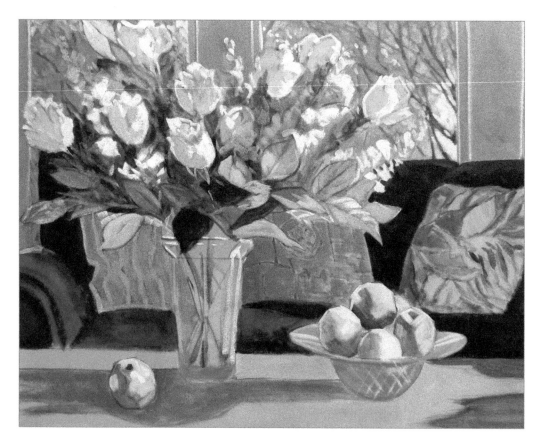

Step 5 To complete the area through the window, I start with a thin layer of ultramarine blue, a little green gold, and glazing fluid. While this layer is wet, I paint into it with white plus touches of green gold and ultramarine blue. I paint a second layer on the dark areas of the sofa with quinacridone gold and dioxazine purple, and paint the lighter areas with quinacridone gold and a little white. A second coat goes on the window frame using mixes of ultramarine blue, quinacridone red, quinacridone gold, and white. The leaves are painted with various mixes of green gold, ultramarine blue, quinacridone gold, and white. Then I paint the apples (see detail on page 69).

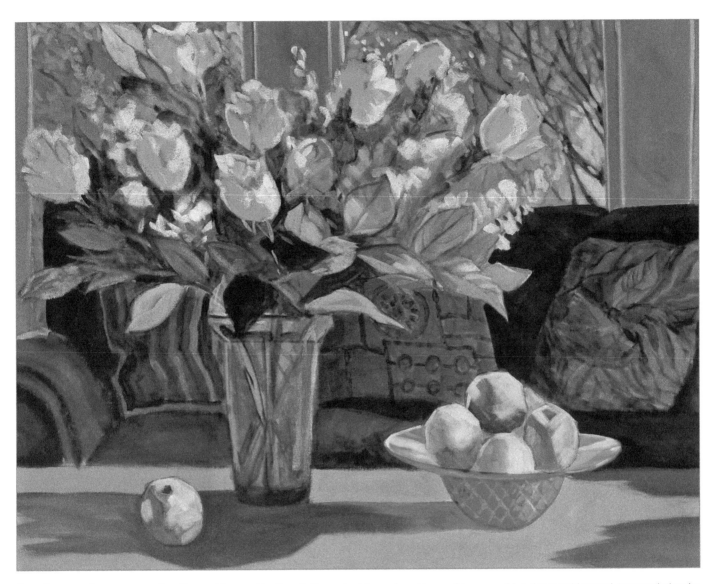

Step 6 Now I paint patterns on the pillows with a combination of ultramarine blue, quinacridone gold, green gold, and quinacridone red. I start painting the stems in the vase with ultramarine blue and green gold. Once dry, I paint over them with a layer of quinacridone gold. I paint another layer on the bowl using mainly ultramarine blue and white with a bit of quinacridone red.

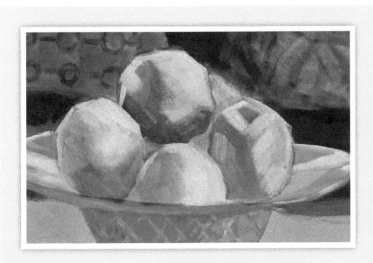

Detail

For the apples, I first paint a glaze of green gold with glazing fluid. Then I stroke white, green gold, and ultramarine blue into the wet layer.

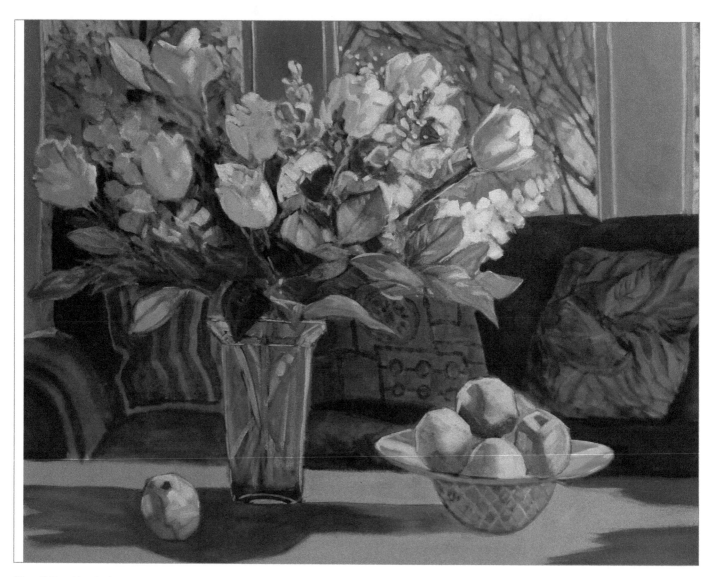

Step 7 Next I begin the roses. I start with a glaze of quinacridone red and Hansa yellow all over each flower; then I work white paint into the wet glaze. For the base of the flowers, I apply a layer of Hansa yellow and green gold. Then I paint the snapdragons (see detail below).

Detail

I paint the snapdragons with a combination of white, ultramarine blue, and Hansa yellow. I vary the colors of the leaves with mixes of Hansa yellow, ultramarine blue, quinacridone gold, and white. Finally, I paint another layer of white on the highlights of the flowers and leaves. Once dry, I warm up some of the white highlights with a layer of Hansa yellow.

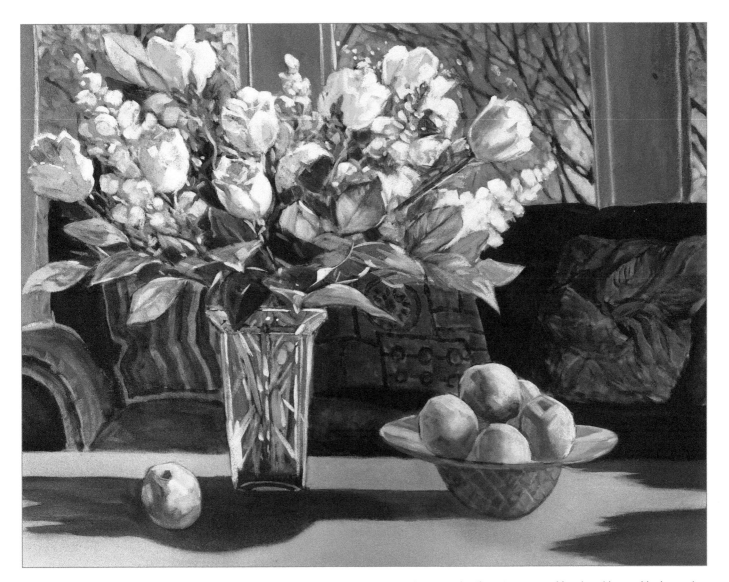

Step 8 To finish the painting, I look for areas that need attention. I finish the vase by adding more details, using green gold, quinacridone gold, ultramarine blue, and white. I reinforce the white with another layer; then I warm up some highlights by glazing with yellow. I apply a layer of green gold and Hansa yellow to brighten the apples. Finally, I paint a few grayish blue shapes on the pillow at right, using ultramarine blue, quinacridone gold, and white.

Detail

Notice that I keep my background elements muted and low in contrast—from the suggestion of trees in the window to the pillows on the couch. Downplaying these areas by avoiding too much detail and contrast allows the main elements of the composition to shine.

Lemons & Teapot

Working with a limited palette (only a few select colors) is a great way to create unity in a painting while keeping it bold and simple. In this project, I use just six colors to bring the scene to life.

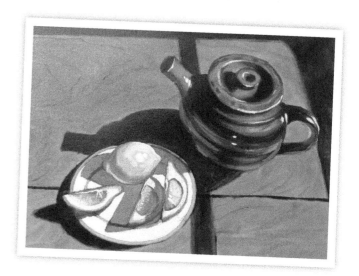

Color Palette

cobalt blue • dioxazine purple • hansa yellow medium
pyrrole red • quinacridone gold • titanium white

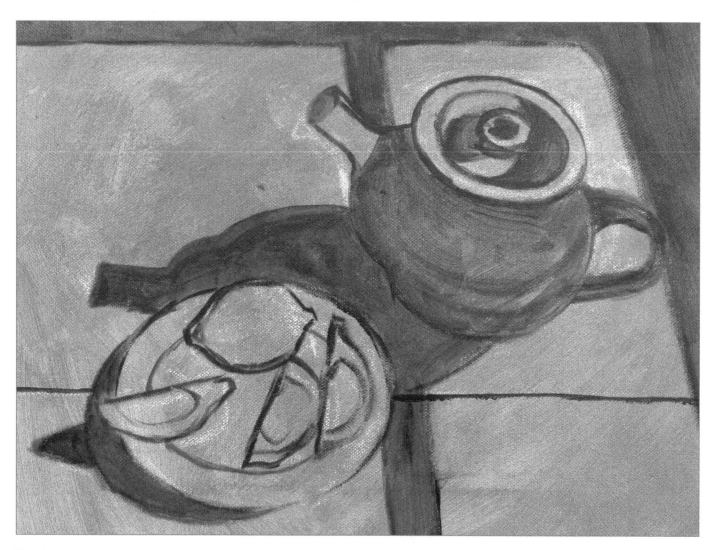

Step 1 To begin, I paint a layer of thinned quinacridone gold over a 12" x 16" canvas. Once dry, I draw the basic shapes of the composition with chalk and go over them with dioxazine purple. I also use purple to block in the shadows.

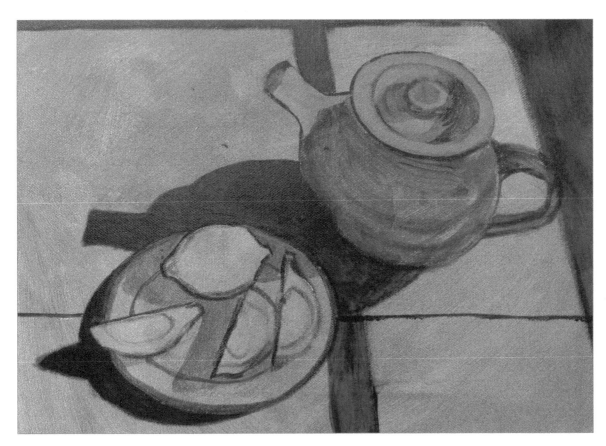

Step 2 Now I paint the lemons with a layer of Hansa yellow mixed with titanium white. Then I paint the shadows on the plate with cobalt blue. I layer pyrrole red and cobalt blue over the spout and lid of the teapot. Finally, I paint a second layer of dioxazine purple and quinacridone gold to deepen the shadows.

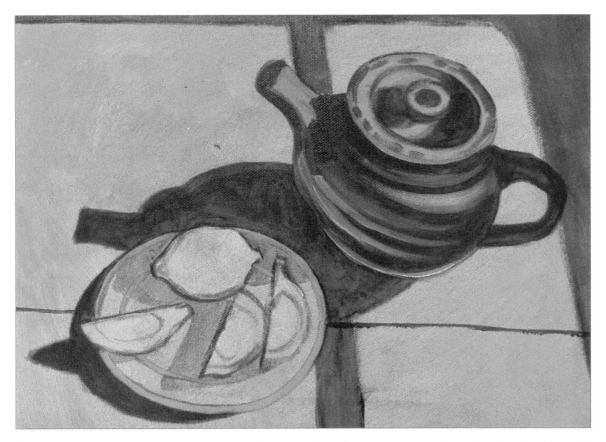

Step 3 I paint the rim of the plate with a mix of cobalt blue and white. For the teapot, I layer over the darks using quinacridone gold and purple mixed with glazing fluid. While the paint is still wet, I paint the highlights with white.

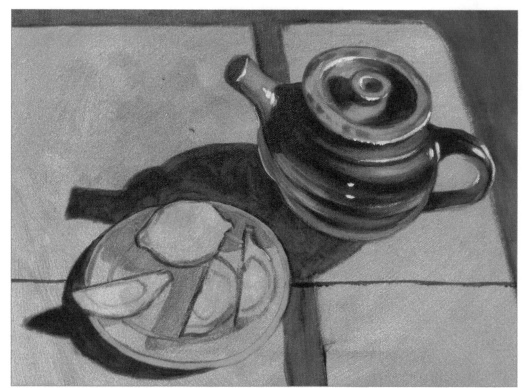

Step 4 Around the rim of the lid, handle, spout, and base of the teapot, I paint a layer of pyrrole red. When dry, I paint a thin layer of cobalt blue mixed with glazing fluid over the highlighted bands of the teapot. To finish this step, I paint white over the brightest highlights.

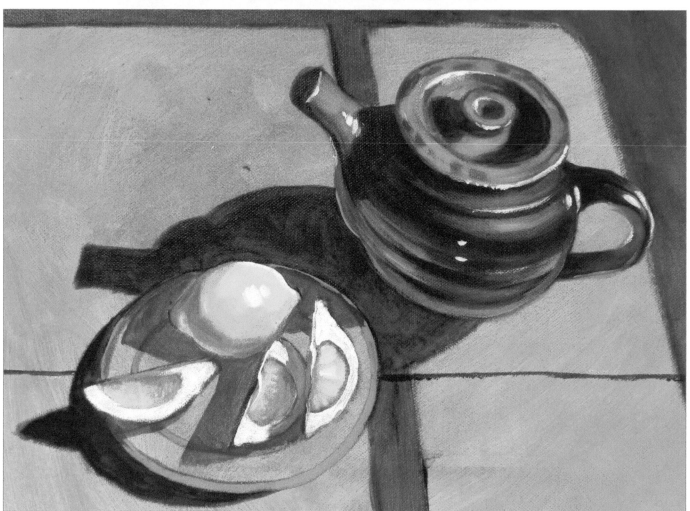

Step 5 To finish the lemons, I start with a layer of Hansa yellow mixed with glazing fluid on each lemon. I use Hansa yellow and white for the lightest areas, Hansa yellow and pyrrole red for the deeper yellow areas, and a combination of cobalt blue, Hansa yellow and pyrrole red for the shadows. For the lightest areas on the lemons, I use pure white.

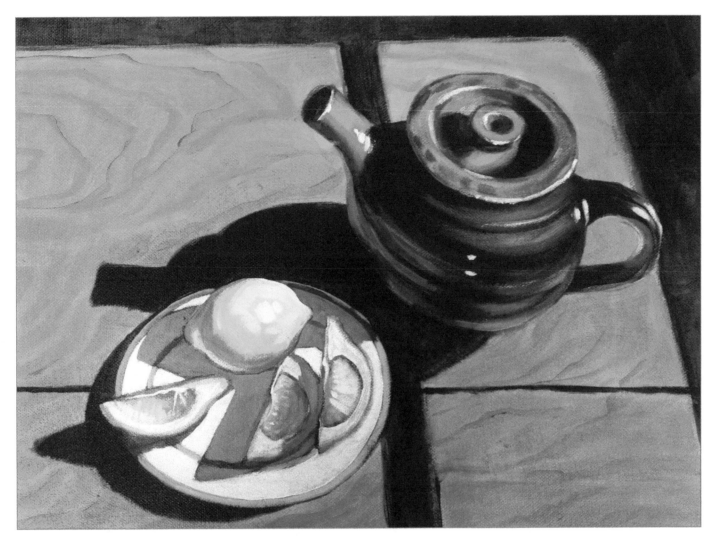

Step 6 For the plate, I apply two layers of white over the light areas. For the shadows, I use cobalt blue and Hansa yellow mixed with a small amount of pyr-role red and white. To complete the painting, I use quinacridone gold and a bit of pyrrole red for the wood grain of the table.

Detail

For a final "pop," I use white to bring out highlights on the lemon and wedges. I also add red-orange to areas of the rind for definition and glow.

Teapot & Apples

In this project, learn how to use a wet-into-wet technique to create softly blended strokes that remain visible and lively. This painterly effect creates energy and movement even in areas of solid color.

Color Palette

dioxazine purple • Hansa yellow medium • Mars black
phthalo blue • pyrrole red • quinacridone gold
titanium white • ultramarine blue

Step 1 To begin, I paint the canvas with a thinned layer of dioxazine purple. After laying in the drawing with chalk, I go over the lines with a small brush loaded with thicker dioxazine purple. Using water to thin my colors, I apply ultramarine blue over the shadows, quinacridone gold over the teapot, and Hansa yellow over the apples. I also paint the dark handle of the teapot with Mars black.

Artist's Tip

Toning your white canvas with a thin, luminous layer of paint adds richness and color unity to a finished painting.

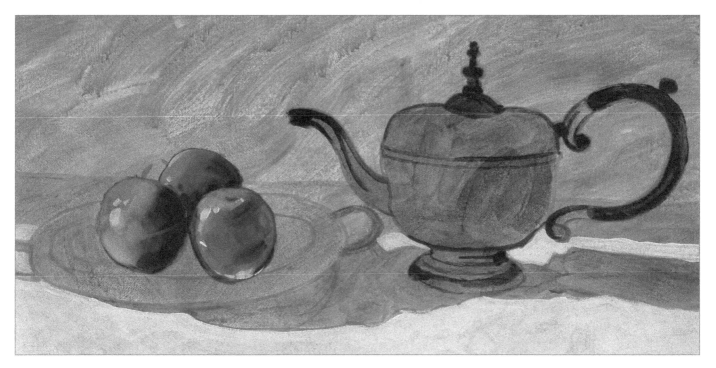

Step 2 Next I paint the apples one at a time, starting with a coat of Hansa yellow mixed with acrylic glazing fluid, which slows the drying time. The trick is to paint them quickly so the colors blend together. I use a combination of Hansa yellow, pyrrole red, phthalo blue, and white. I apply the white highlights last. In this step, I also add more darks to the teapot with a mix of ultramarine blue, pyrrole red, and Mars black.

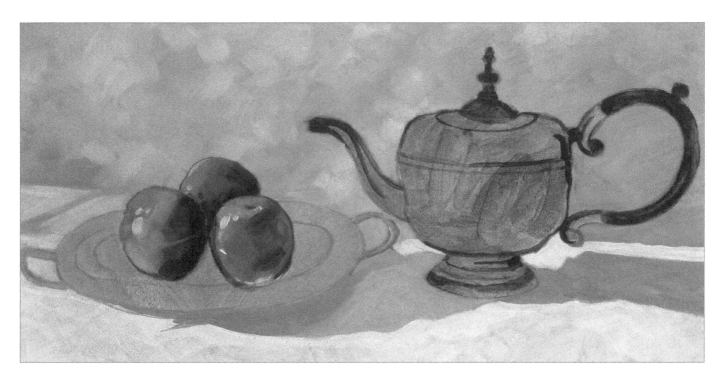

Step 3 Now I paint the background and tabletop with a combination of white, ultramarine blue, and pyrrole red. I also add a bit of quinacridone gold to the mix in some areas to gray down the violet color. I use a 1" brush for this and change the direction of the brushstrokes often to create texture.

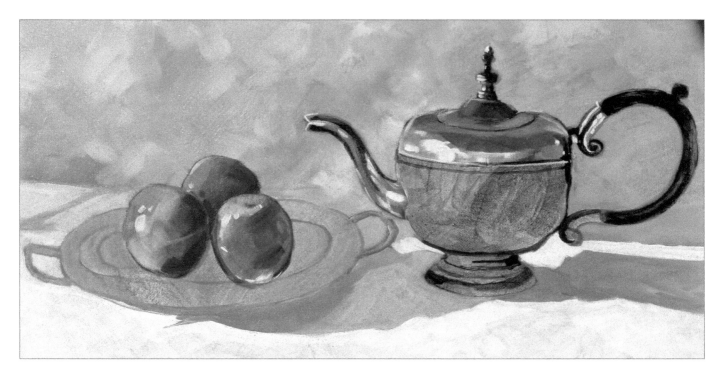

Step 4 For the teapot, I start by laying a thin layer of quinacridone gold and glazing fluid. I add mixes of ultramarine blue, pyrrole red, Mars black, white, and more quinacridone gold. I try to set in the darks first, adding the lighter colors last. I work in one area at a time, allowing me to work wet-into-wet.

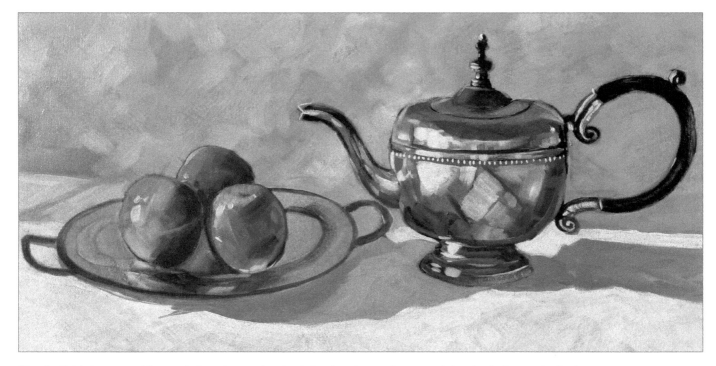

Step 5 I finish the teapot with my variations of gray, using chunky brushstrokes as I focus on painting the shadows and reflections.

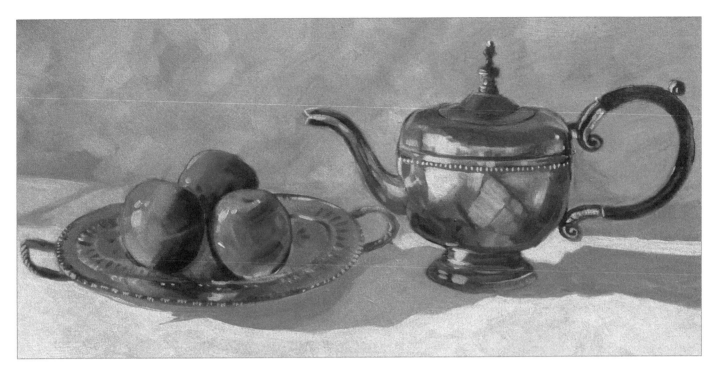

Step 6 Then I move on to the plate, adding reflections with Hansa yellow, pyrrole red, ultramarine blue, and white. For the darkest areas, I use ultramarine blue, pyrrole red, and a little black. I use a small round brush to paint the white highlights last. I apply a very thin layer of quinacridone gold and Hansa yellow (thinned with glazing fluid) over the teapot to warm it up.

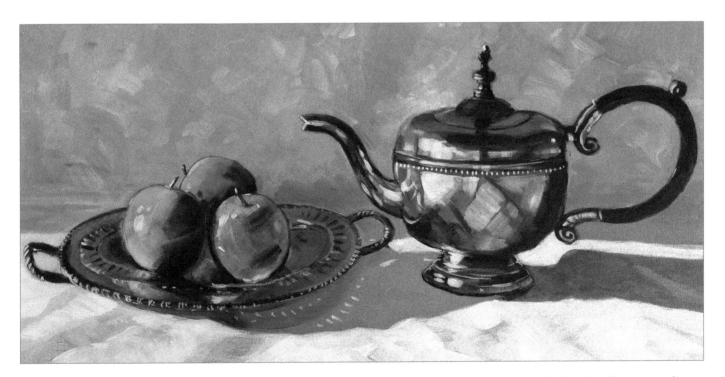

Step 7 To complete the painting, I focus on the background. I mix ultramarine blue, pyrrole red, white, and glazing fluid and work wet-into-wet over the background. For the lightest areas, I paint a thin layer of ultramarine blue, pyrrole red, and glazing fluid first; then I work pure white into the wet glaze. I finish by adding a few final details throughout the piece.

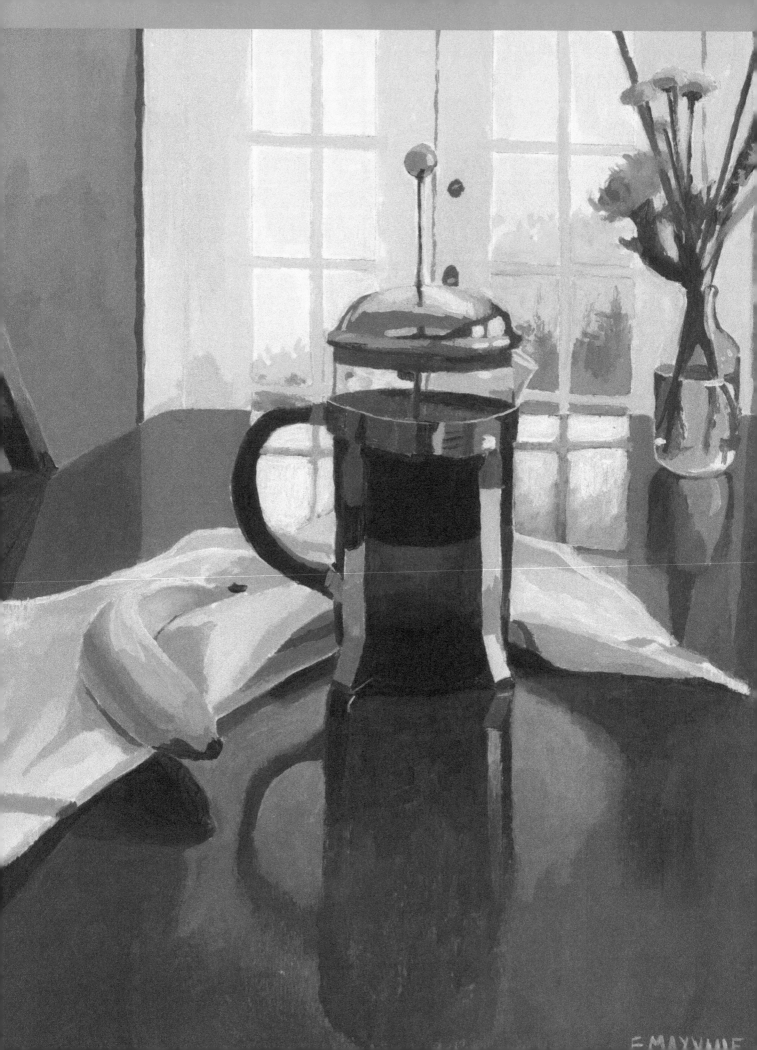

CHAPTER 4

Everyday Inspiration

with Elizabeth Mayville

Elizabeth Mayville's crisp, clean style turns everyday scenes into calm, intimate works of art. From a simple neighborhood view from a windowsill to scattered toys on the stairs, this chapter holds both traditional and unconventional subjects for a more detailed look at what defines a still life.

Stack of Books

The flat surfaces of books make them great subjects for studying planes and light. Notice how the crisp edges of the books contrast with the more organic color shifts in the foreground. The defined shadows of this scene add to the depth and contrast.

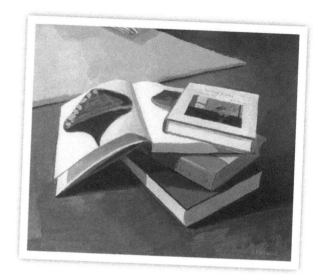

Color Palette
alizarin crimson • burnt umber • cadmium red medium
cadmium yellow light • phthalo blue • titanium white
ultramarine blue • yellow ochre

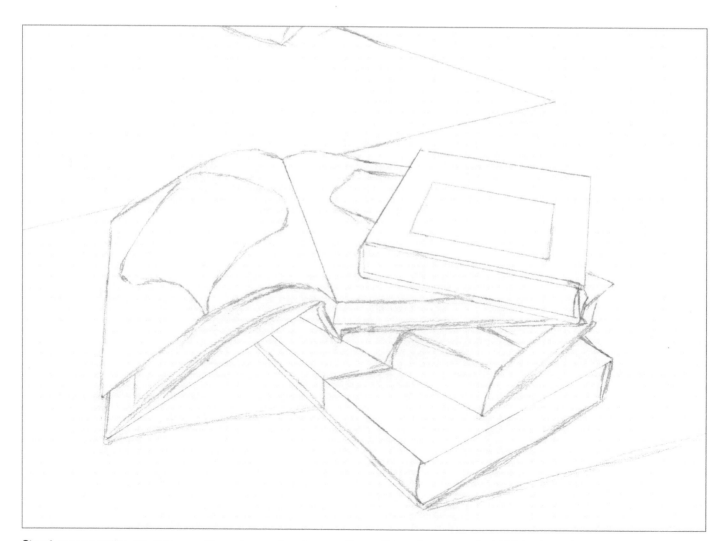

Step 1 I use a pencil to draw the composition on heavy watercolor paper. Some artists prefer to create the initial drawing with paint so the pencil doesn't muddy up the colors, but I like some of the line to show through in the finished piece. Executing an accurate drawing is important; with this many angles, getting the perspective wrong in a few spots can throw off the entire composition.

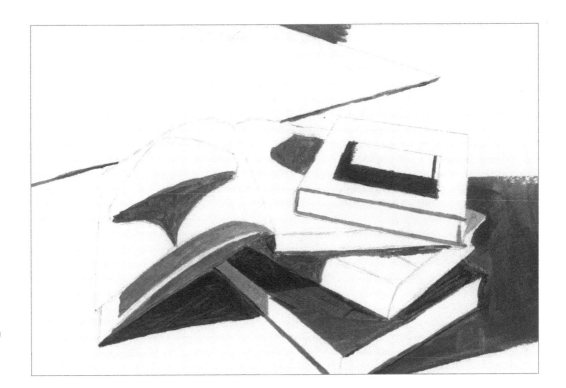

Step 2 Now I fill in the darkest spots of the painting. For the shadows on the floor, use a combination of burnt umber and ultramarine blue. Paint the black book with the same colors, using more blue than brown as well as a little more white for the areas in light. For the dark green bits, mix phthalo blue, ultramarine blue, yellow ochre, and burnt umber.

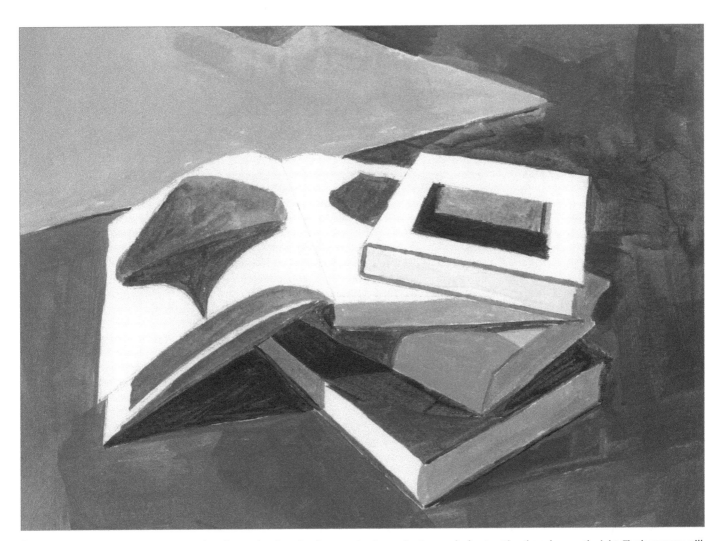

Step 3 Next I fill in the mid-range tones, keeping my brushstrokes loose and not worrying too much about getting the color exactly right. The looseness will add some movement to the finished painting, and remember that you can always correct colors later. The most important part is to get the paper covered while getting an idea of the color relationships you want to develop in the painting.

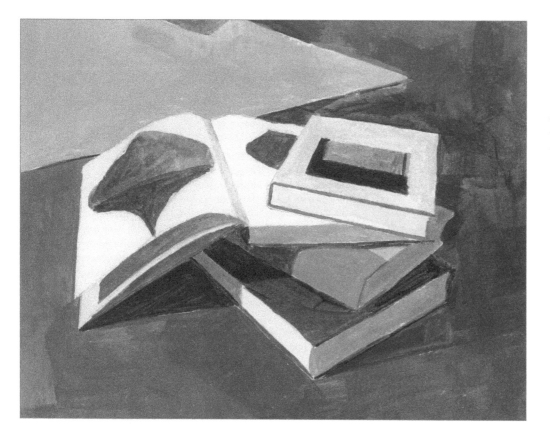

Step 4 At this point, I block in the lights. I use white with a little ultramarine blue for the pages of the open book and black book. I paint the cover of the top book with a mix of white and both yellows in my palette. I avoid pure white when painting lights because few things in this world are actually white. Instead, I reserve my brightest white for the occasional highlight.

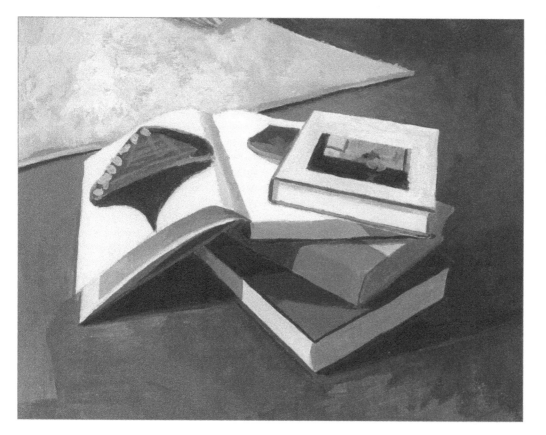

Step 5 To begin refining the painting, I darken the floor shadows with more burnt umber and ultramarine blue. I also address the rest of the floor with varying washes of burnt umber, yellow ochre, cadmium red medium, and white. I add stripes to the pillow at the top of the frame and apply a wash of white and yellow over the rug.

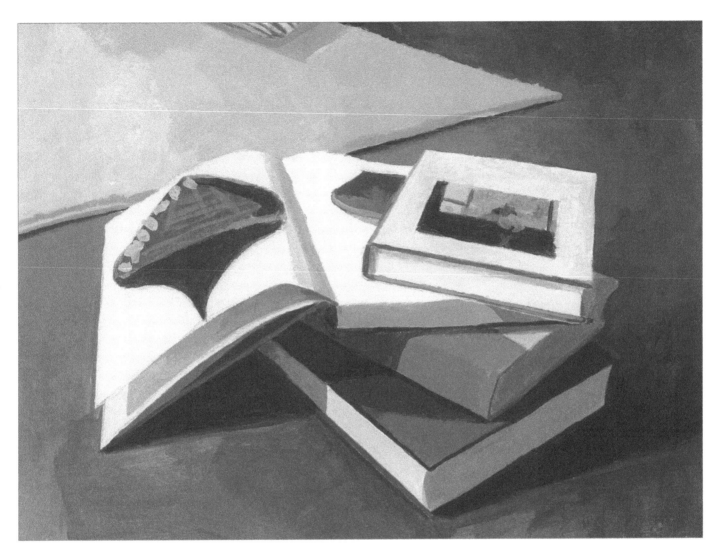

Step 6 I darken the shadows and tone down the rug with additional washes, darkening as I move from left to right. I apply a wash of white, ultramarine blue, alizarin crimson, and yellow ochre over the portion of the rug farthest to the right. As I move left across the rug, I add more white and yellow to the mix.

Artist's Tip

If your composition feels a bit stagnant, try adding another object. In this painting, I've added the corner of a striped pillow to the top, which serves to redirect the eye down to the books.

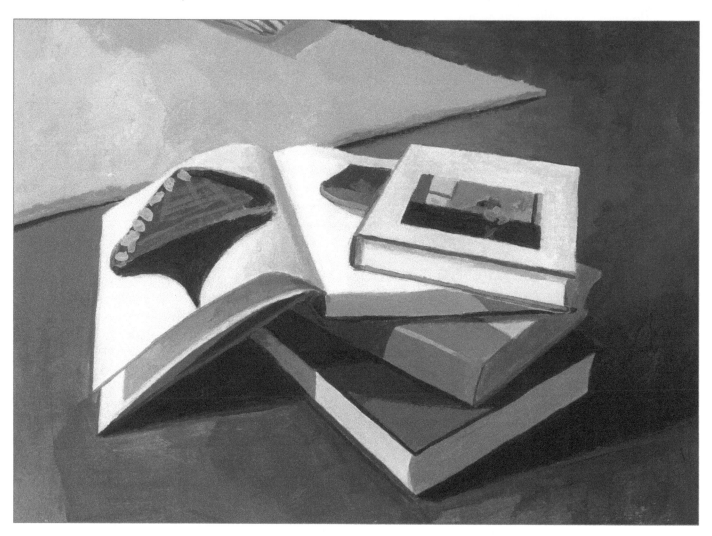

Step 7 Now I refine the lightest areas and add some highlights. The shift from light to shadow appears too harsh on the pages of the open book, so I add some darker values between the lightest and darkest areas.

Page Sequence

Page A

Page B

Page C

Page D

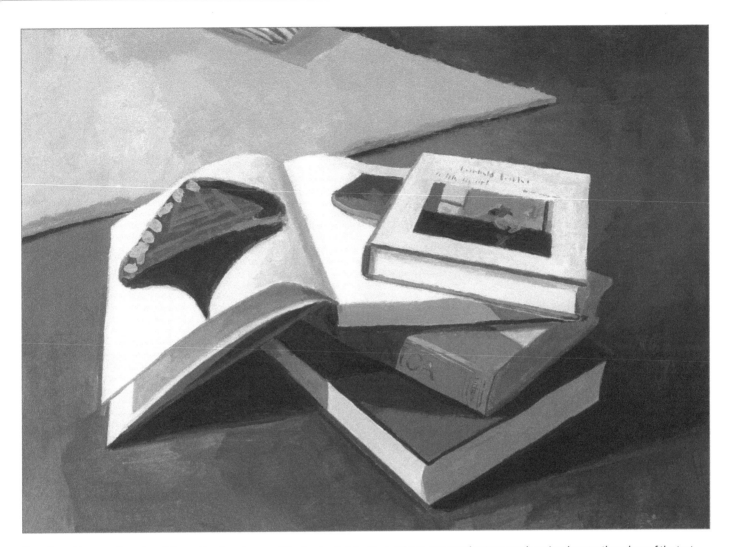

Step 8 I add text to the spine of the teal book and cover of the top book. I don't want the text to stand out too much, so I make sure the values of the text aren't too different from the value of the books. The text on the teal book is gold, so I paint it first with a brownish mix. Then, using a mix of white and both yellows, I go over the parts that catch the light. To finish, I add just a bit of a highlight with cadmium yellow and white.

Detail

Unless the text is the focus of your painting, avoid writing and replicating exactly as it appears in your reference. I find it more helpful to instead focus on the general shapes of the letters in perspective. This will help keep the text from seeming hyper-refined against a generally loose painting.

Butter

Butter is a treat for the palette as well as the palate. I love to paint butter because it involves plenty of subtle color shifts, both in the butter itself and in its waxed paper wrapping. Due to the complexity of the subject matter, I find it a good idea to leave the composition simple and straightforward.

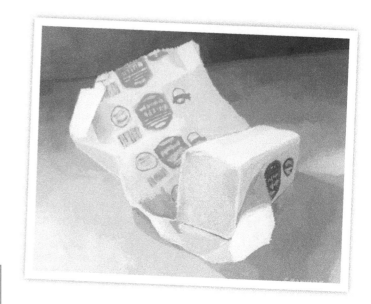

<div style="border">

Color Palette

alizarin crimson • burnt umber • cadmium red medium
cadmium yellow light • phthalo blue
titanium white • ultramarine blue • yellow ochre

</div>

Step 1 I use pencil to draw the butter on heavy watercolor paper. After developing and refining my sketch, I lightly erase the pencil so that just a ghost of the drawing remains. This step is particularly important if your subject is light in value.

Step 2 I block in my dark values with a mix of ultramarine blue and burnt umber. I use more ultramarine blue for the spots on the waxed paper, and I use more burnt umber (with only a dab of ultramarine blue) for the background. The light source is coming from the left, so I add white and yellow ochre to lighten as I move toward the left.

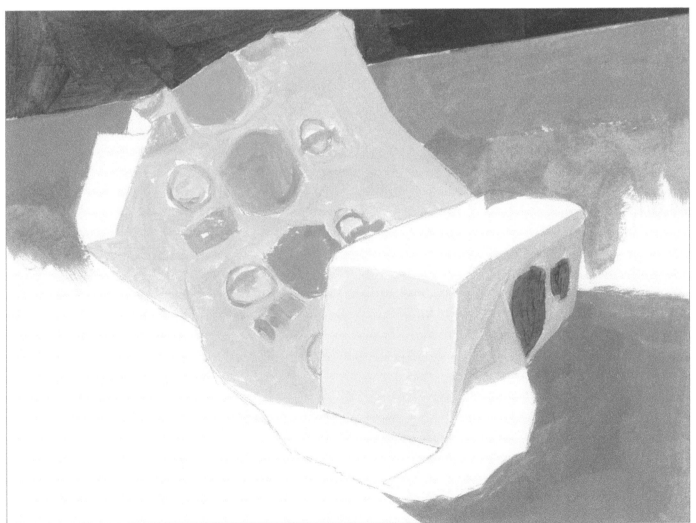

Step 3 Now I block in the mid-range values. I paint the waxed paper with white, ultramarine blue, and alizarin crimson. I use the same mix in the foreground and background with a little yellow ochre added to warm it up. The front of the butter includes mostly white with a bit of yellow ochre, cadmium yellow light, and cadmium red medium. The side also calls for plenty of white with a bit of ultramarine blue, yellow ochre, and cadmium yellow light.

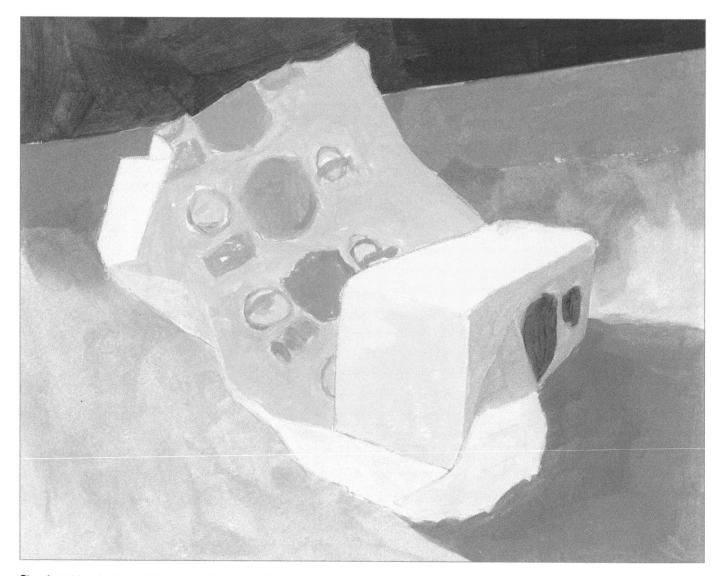

Step 4 At this point, I quickly block in the light values. The key to this painting is capturing the subtle shifts of color, so when I move from area to area, I alter my paint mixes just a touch. I paint the top of the butter white and yellow. I go over the lightest part of the waxed paper with white, both blues, and alizarin crimson. The light portions of the foreground and background use the same colors as the waxed paper, plus a touch of alizarin crimson.

Artist's Tip

To keep the painting unified, develop it as a whole. Work all over the surface as you move from dark to light, and avoid focusing on one area from start to finish.

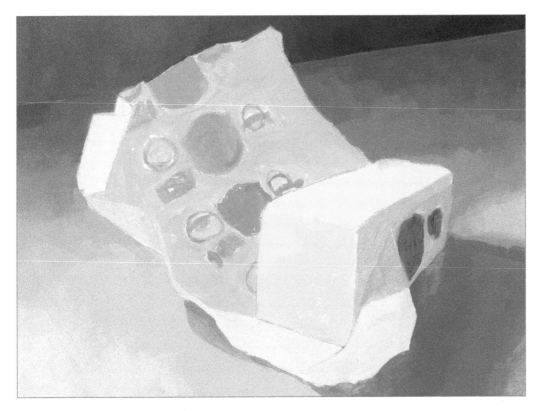

Step 5 Next I focus on refining the background and foreground. I focus on darkening the shadows, lightening the light areas, and adding little shifts of color in otherwise barren areas. I also make sure to have a little light spot to the right of the butter, which defines the shadows and draws the eye all the way across the painting.

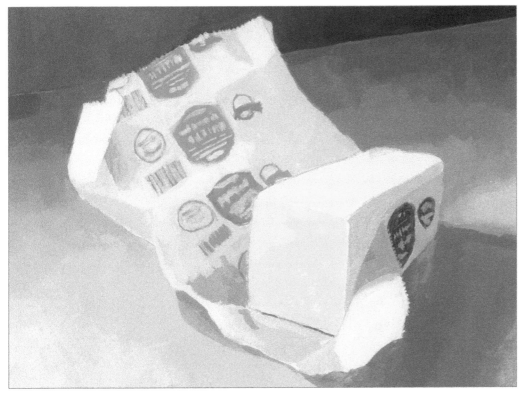

Step 6 Now I work on the waxed paper, which is perhaps the most challenging part. I don't want to change the overall value structure of the paper, so I have to make small adjustments to areas that are darker or lighter. I simply add a bit of white and phthalo blue to the lighter areas.

Detail

When addressing the graphics, I keep them pared down and general without any recognizable words or logos.

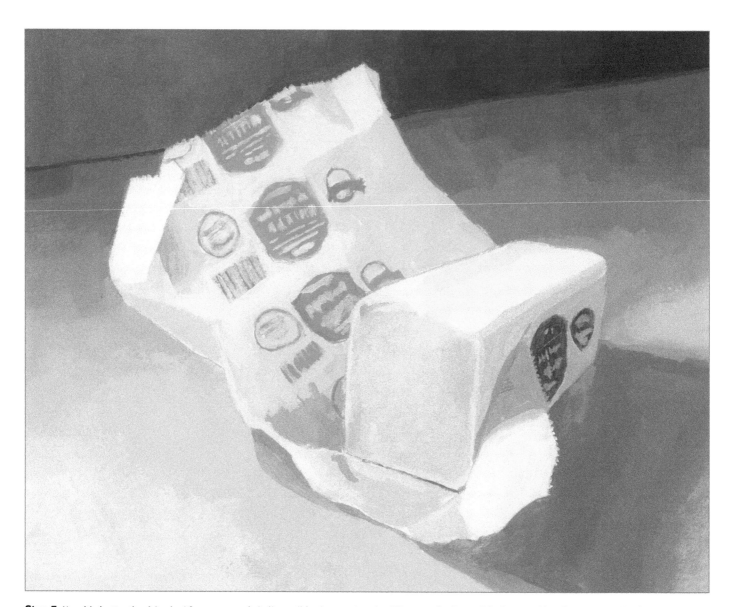

Step 7 Now it's butter time! Again, I focus on nearly indiscernible changes in color. Warm up the front of the butter with a tiny amount of cadmium red mixed with a ton of white and a little cadmium yellow. To counter the warmth of the red in some spots, I add touches of yellow ochre and ultramarine blue.

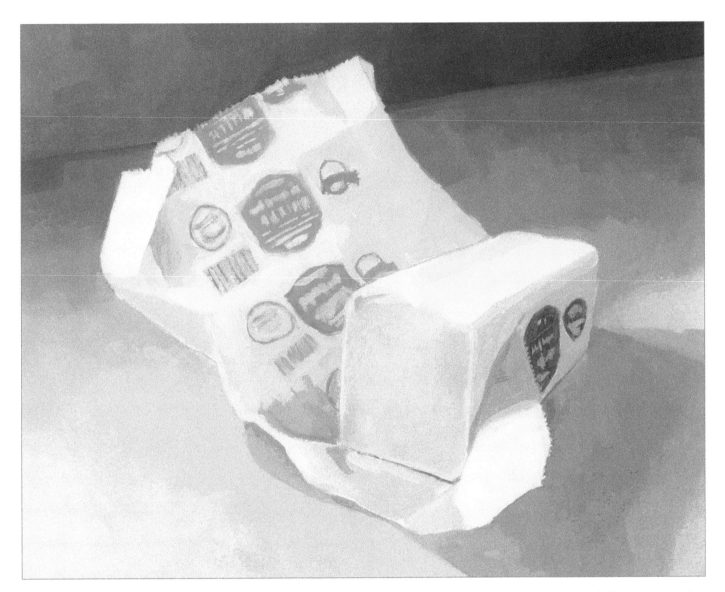

Step 8 I am unhappy with the darkness of the butter's cast shadow, so I lighten it up and cool it down with small amounts of phthalo blue. I keep my paint mixes wet throughout the painting, so I'm always using mixes from one area in other areas. This helps to create visual harmony throughout the painting—and it also helps conserve paint!

Artist's Tip

Don't be afraid to exaggerate color! My finished painting is not the spitting image of my still life setup, but it is more interesting and dynamic.

French Press

Because this still life features so many reflections, remember to work on the painting as a whole instead of developing separate areas at a time. Using a color mix throughout a painting, rather than in just one area, can help create a cohesive image with visual unity.

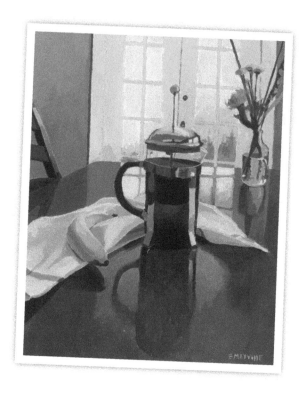

Color Palette

alizarin crimson • burnt umber • cadmium red medium
cadmium yellow light • phthalo blue
titanium white • ultramarine blue • yellow ochre

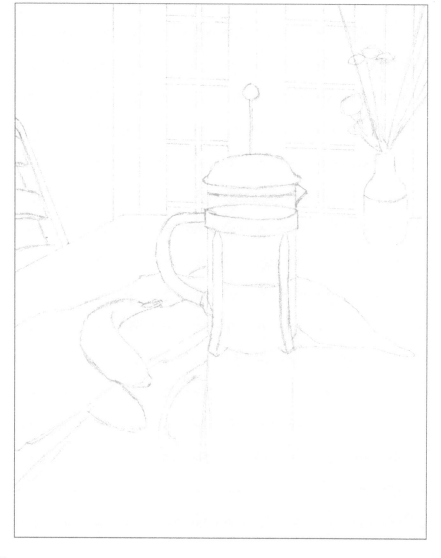

Artist's Tip

Generally speaking, it's not a good idea to place your focal point in the dead center of a composition, as it can create a dull image with little movement. In this painting, I decided to do it anyway and added several compositional elements that direct the eye right back to the center. Sometimes it's OK to break the rules if you do it with intention and enthusiasm!

Step 1 I use a pencil to draw my composition on a sheet of heavy watercolor paper. I make some parts of the sketch accurate, such as the curve of the banana, but leave other areas loose, such as the flowers in the background. This will help the viewer focus on the foreground objects rather than the loosely rendered background.

Step 2 Next I fill in the darks, beginning with a mostly dark brown mix of burnt umber and ultramarine blue. I paint the handle of the French press and shadow by the door with the same colors, adding more blue to the mix than brown.

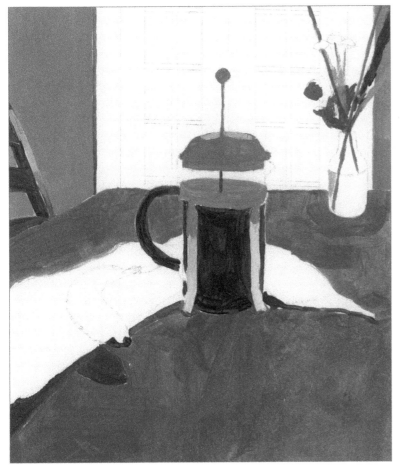

Step 3 Now I block in the middle values. I begin the table by painting it with a coat of solid brown, which gives it the foundation for a sense of unity as I develop it. This initial color also keeps the task from feeling overwhelming. In an area that could become complicated, it's best to begin with a quick, basic underlying color so that you can build momentum before you get discouraged. Then you can return to the object and refine it until you're satisfied.

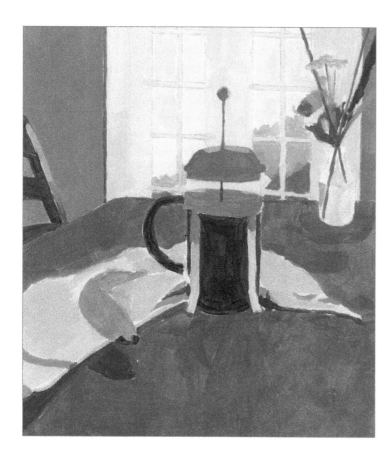

Step 4 In this step, I block in the light values. I am careful to make sure these doors—although white in terms of local color—are darker than what we can see of the brighter outdoor world in the background.

Step 5 Now I address the table. I begin by darkening areas in shadow and move on to highlighted areas reflecting light. Through a series of small adjustments, I work on creating an effective amount of contrast while making sure the table reads as a solid surface.

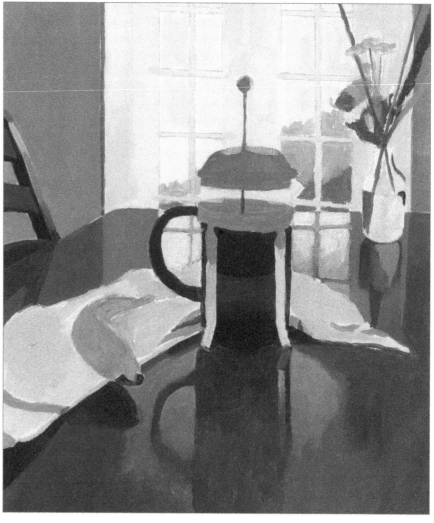

Step 6 Now I refine the dishtowel and banana. The dishtowel is a bit tricky because it has only a few high-contrast areas and could easily read as flat and boring. The trick is to really examine the subtlety of color and make small, smart shifts in color and value. I paint the banana with a mix of warmer yellows for its shadowed areas along with cooler yellows and greens for the areas in light.

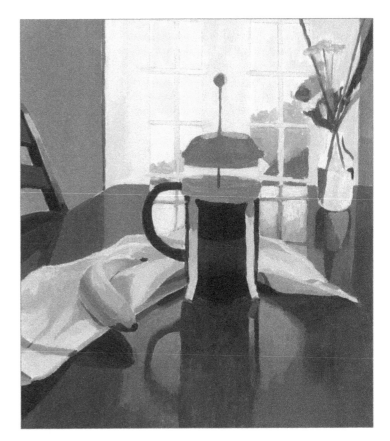

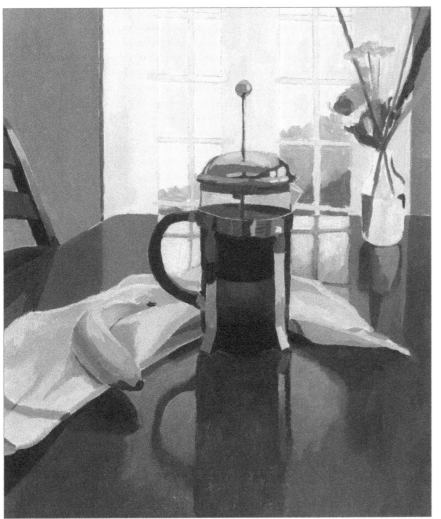

Step 7 Next I move on to the French press. I enjoy painting reflective metal because it allows me to use several paint mixes from my palette—and if I get it right, the visual payoff is huge! I make sure the value structure is accurate; otherwise, it won't read as reflective. I use paint mixes from the table, towel, and banana as well as some new grays made with ultramarine blue, burnt umber, and white.

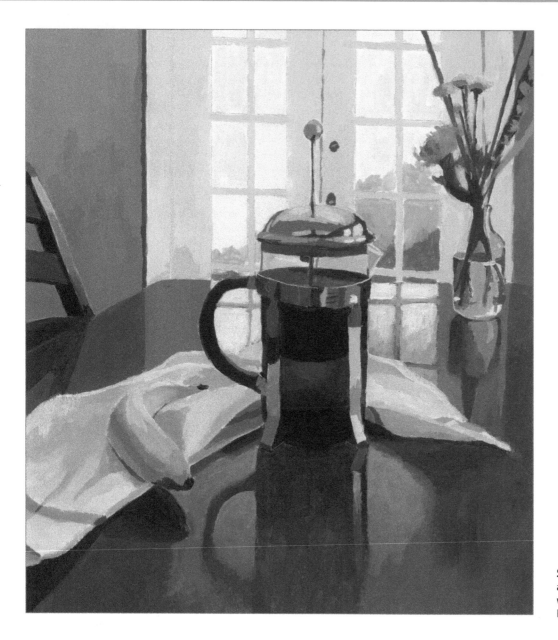

Step 8 Now I sort out the flowers and back wall. I also darken the walls and doors and add minimal highlights and shadows.

Detail

I paint the flowers loosely, using only one dark value and one light value for each kind of flower. This helps keep my strokes fresh and lively.

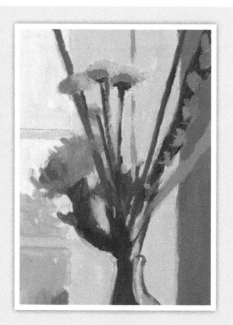

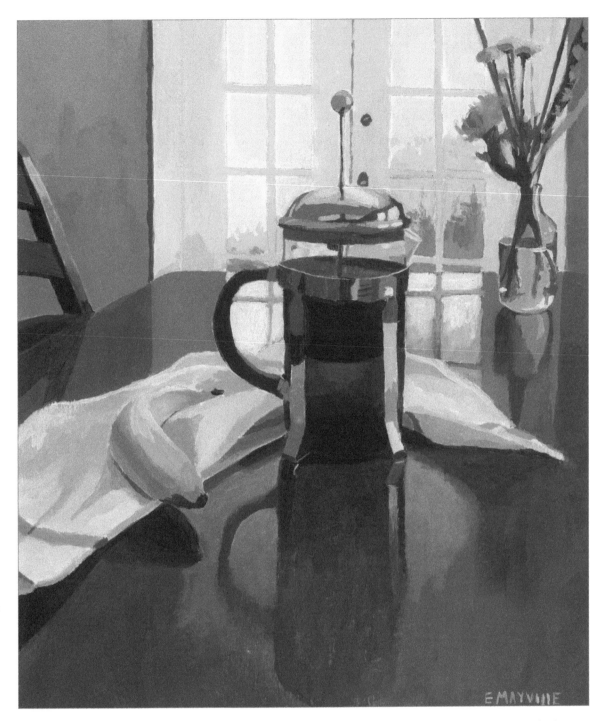

Step 9 I quickly address the far background, refining the greenery and putting down another coat of light orange to help clean up the crossbars of the French doors. I also take a step back to see if there are any areas that look unfinished. As it turns out, the space just under the French press looks off, so I return to add more shadow and a small reflection.

Artist's Tip

Don't be afraid to paint glass! If it's clear glass, then it's pretty much a jigsaw puzzle made up of other colors from your painting. Be very attentive to the shapes created by the different planes of color, and don't get distracted by what you think the glass object should look like.
Paint what you see, and it will pull together in the end.

Windowsill

Still life scenes aren't limited to fruit, flowers, and tabletop scenes. In this painting of the view from my desk, I sneak in elements of a landscape through the window for depth and interest. If you choose to do this, focus most of your attention on the foreground so it acts as the obvious focal point. Whatever lies beyond the window should rest comfortably in the background, a little muted in color and painted loosely.

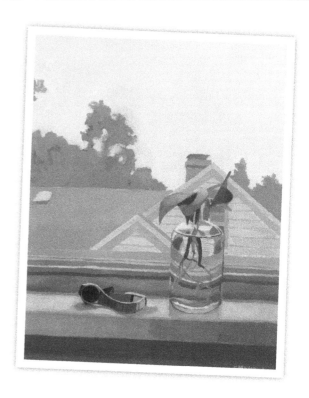

Color Palette

alizarin crimson • burnt umber • cadmium red medium
cadmium yellow light • phthalo blue
titanium white • ultramarine blue • yellow ochre

Step 1 I draw the composition with pencil on a piece of heavy watercolor paper. I add the horizontal lines of the windowsill and the house in the background using a ruler to make certain they're straight.

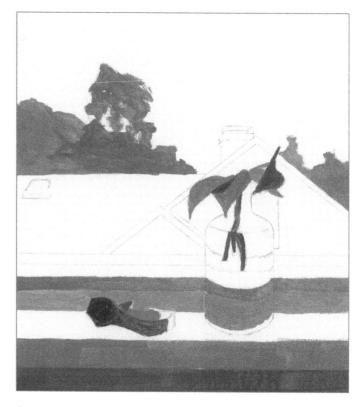

Step 2 Now I block in the darks of the composition. The greens are a mix of cadmium yellow light, ultramarine blue, and phthalo blue. If I need to warm up the green, I include more ultramarine blue. If I need to cool down the green, I use more phthalo blue.

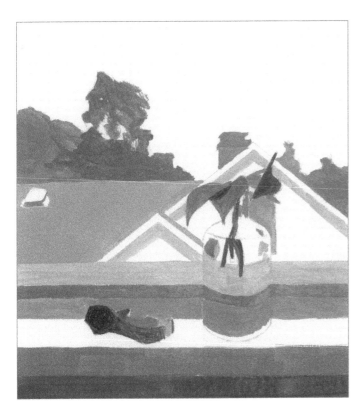

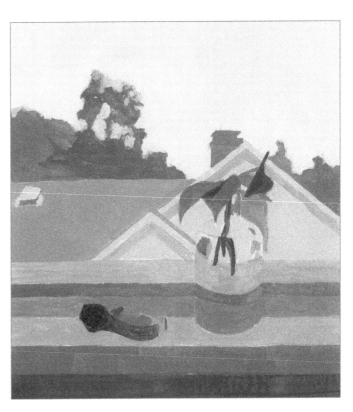

Step 3 Next I block in the middle values. This painting isn't very high contrast; it is made up mostly of middle values. As a result, the process of blocking in each value group separately has more to do with organizing myself and less to do with establishing dark darks and light lights.

Step 4 I block in the light values and decide to go with a pink sky. It's not an accurate depiction of my still life setup, but the composition is fairly straightforward, so the unexpected color adds some visual interest.

Step 5 In this step, I refine the dark areas. I deepen the black of the watch face and paint the band with a combination of yellow ochre, cadmium yellow light, cadmium red medium, ultramarine blue, and titanium white. I add highlights and subtle shifts of color to the greens of the leaves in the jar. I paint the lighter parts of the leaves with a mix of cadmium yellow light and phthalo blue, while I paint the deeper areas with more ultramarine blue and cadmium yellow light with a touch of yellow ochre.

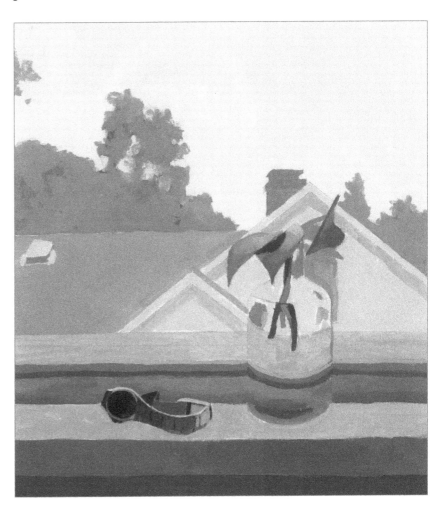

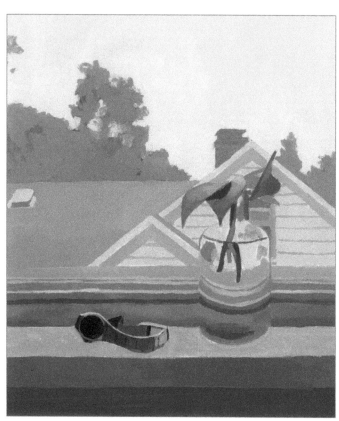

Step 6 At this point, I add some loose details to the rooftop in the background. I want to add just enough visual interest so that the background adds to the overall painting but doesn't distract.

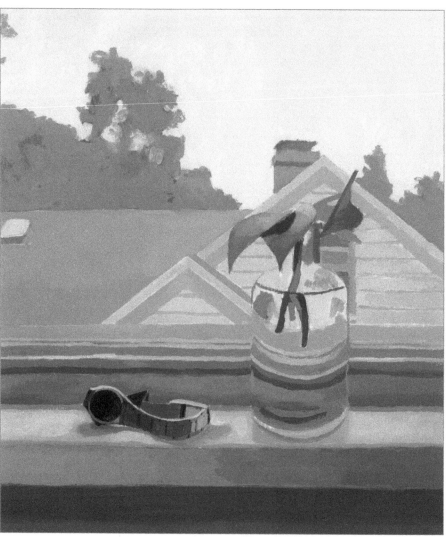

Step 7 Now I sort out the light areas. I darken the white area of the rooftop to help it fade into the background a bit more. The windowsill was reading too warm, so I cool it down with a wash of white, ultramarine blue, and a little alizarin crimson.

You've probably heard some people say, "I could never be an artist; I can't even draw a straight line." Well, drawing a perfectly straight line is serious business—and after a decade of being a professional artist, I've finally admitted to myself that I cannot freehand a straight line. It's OK. That's why rulers and straightedges exist. Take the extra time to grab a ruler when drawing out your composition. You don't have to use it everywhere, but using it on important compositional elements, especially architectural elements, will help keep a painting crisp and structured.

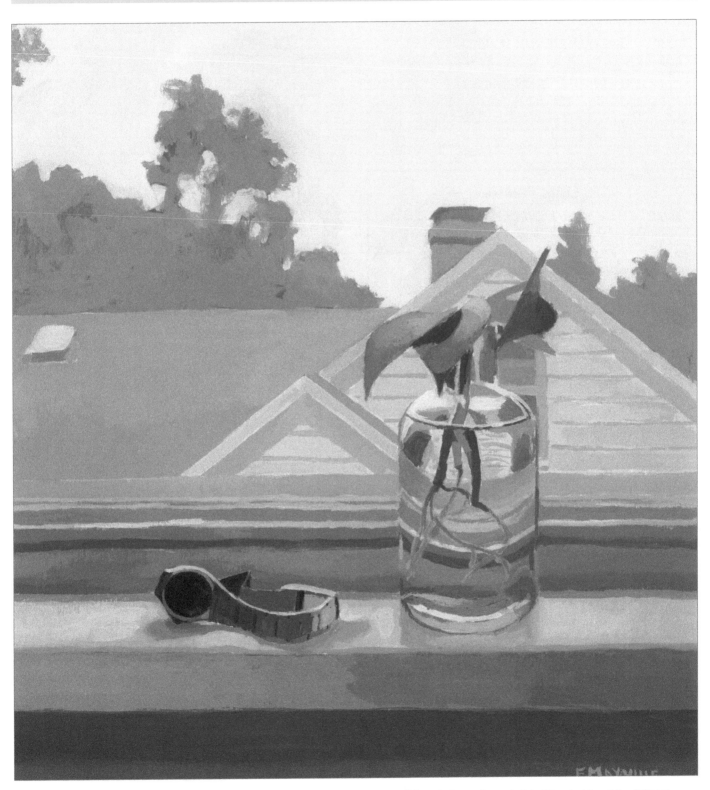

Step 8 Finally I add some detail to the bottle. This is going to be the most exciting part of the painting, so I spend a lot of time looking at the different shapes and making sure the highlights are accurate. I also add roots growing from the leaf stems. I wait until the end for these because they're quite delicate, and it would be a hassle to paint around them throughout the course of the painting. Once I've worked out the bottle, I clean up the pink sky and lighten it just a little. This painting is now complete!

Toys

Instead of using my small studio space to arrange props for my still life setups, I use well-lit areas around my house and incorporate meaningful backgrounds. In this painting, I depict some of my son's toys waiting to ambush the next person who might come down the stairs. The different levels provided by the stairs create an interesting composition, and the primary colors of the toys offer me the chance to use a bold palette.

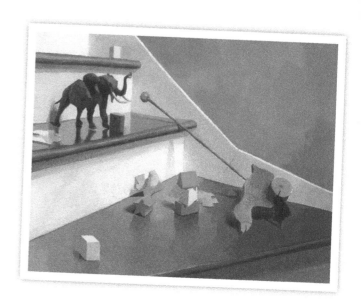

Color Palette

alizarin crimson • burnt umber • cadmium red medium
cadmium yellow light • phthalo blue • titanium white
ultramarine blue • yellow ochre

Step 1 I draw the composition on heavy watercolor paper with pencil. I use a ruler for all of my straight lines and make sure the angles are correct. I pay particular attention to the stacked blocks because they sit in the center of the painting, with several lines pointing to them. If the angles are off, it will be very obvious to the viewer.

Step 2 Next I fill in the darks. I paint the toy elephant with a dark mix of burnt umber, ultramarine blue, and titanium white.

Artist's Tip

No matter the subject matter, I always approach a painting the same way: First I draw the composition; then I block in the dark values, followed by the medium and light values. Then I settle in for the bulk of the work, refining each part of the painting.

Step 3 Now I block in the medium values, which cover a good portion of this painting. For the cool brown of the duck on a stick, I mix a little ultramarine blue and yellow ochre with burnt umber and white. I treat the floor with a warmer mix of burnt umber, cadmium yellow light, and cadmium red medium.

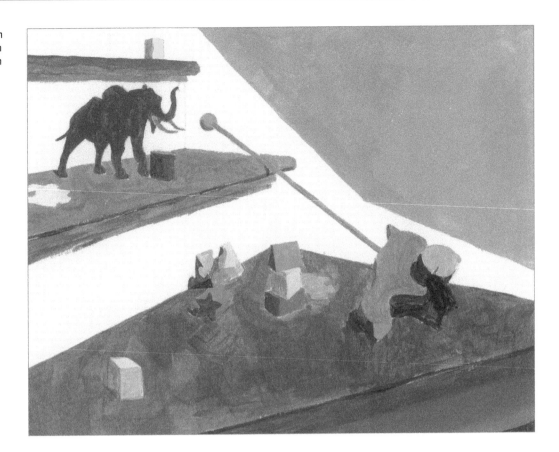

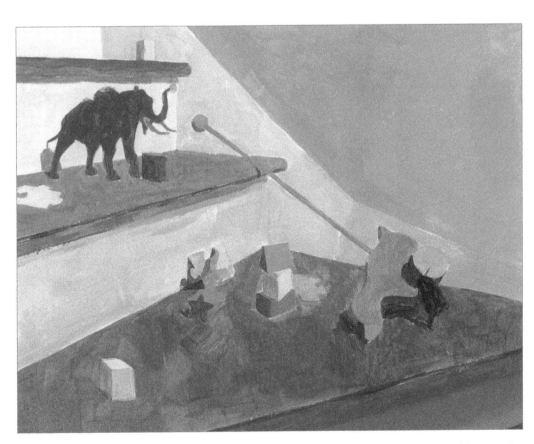

Step 4 Next I block in the light values. I add cadmium red and alizarin crimson to the white of the molding near the second step, as it is reflecting the color of the red knob at the end of the duck's stick. I go a little overboard with this color at the very top, which I'll tone down later.

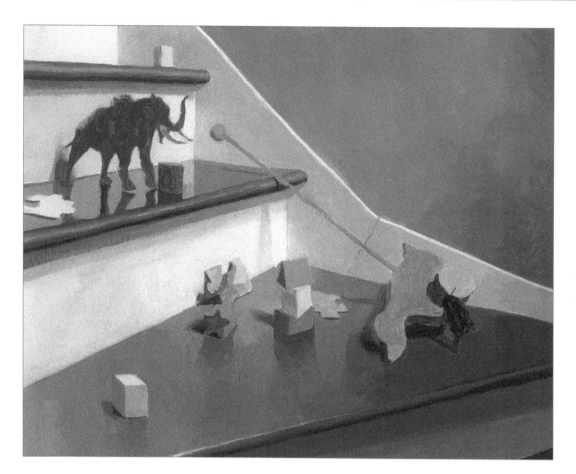

Step 5 In this step, I dive into the stairs and wall. I refine these areas first because I can develop them quickly, and the speed of the process will give me the confidence to tackle the remaining areas. I shade the left sides of the stair risers using white, ultramarine blue, and a bit of burnt umber. As the eye moves right, the risers move into direct sunlight, so I add more titanium white and a touch of cadmium yellow light. I take into account all the brown color shifts of the stair treads—both major and subtle. For the wall, I start from the left (where the light is strongest) and apply a mix of phthalo blue, ultramarine blue, yellow ochre, alizarin crimson, and white. As I move right, I add more ultramarine blue, burnt umber, or yellow ochre.

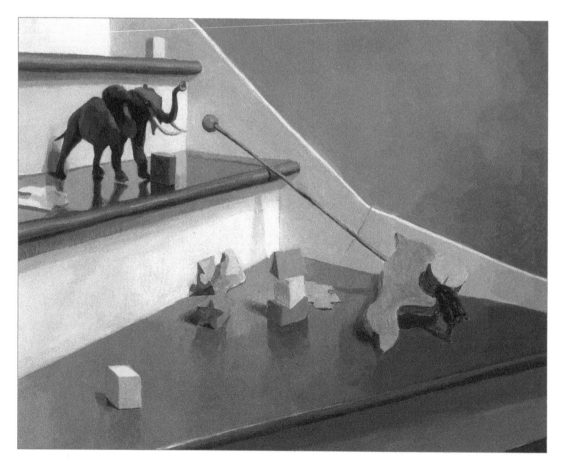

Step 6 In this step, I work on the elephant. The lights of this toy aren't very light, so I am careful not to create too much contrast within the grays. I try to see the elephant as part of the overall composition, rather than a focal point that requires plenty of detail. The elephant acts as an interesting dark spot before the eye moves to the duck.

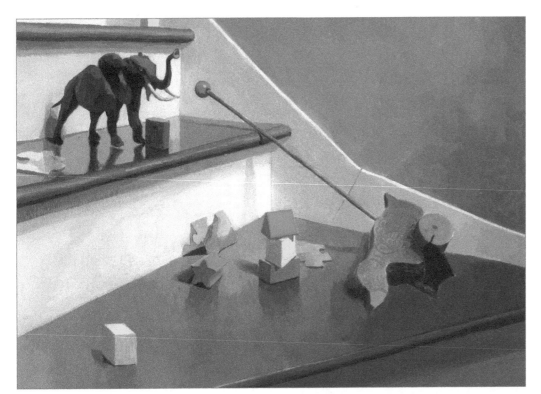

Step 7 Refining the duck mostly involves a few color adjustments on the wheel, such as darkening the foot and adding green. The feathers and eye are hand-painted on the toy, so they are easy details to re-create with my brush. Then I move on to the color shifts of the blocks, which is an exercise in color theory. It takes some work to get the light, medium, and dark values right to create a convincing cube. In these cases, it's always a good idea to test your colors on scrap paper before applying them to your painting.

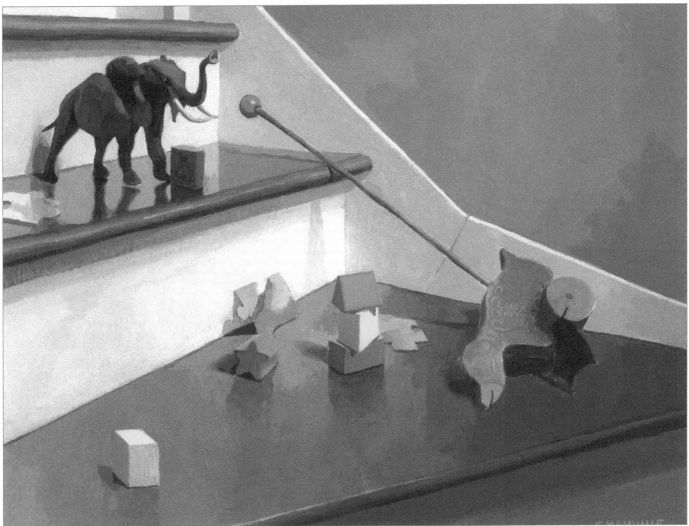

Step 8 At this point, I decide I'm not satisfied with the wall and stair tread (left of the duck). I rework the wall with a larger brush so the strokes aren't distracting, and I darken the stair with a deep grayish-brown. Last but not least, I add the duck's smile!

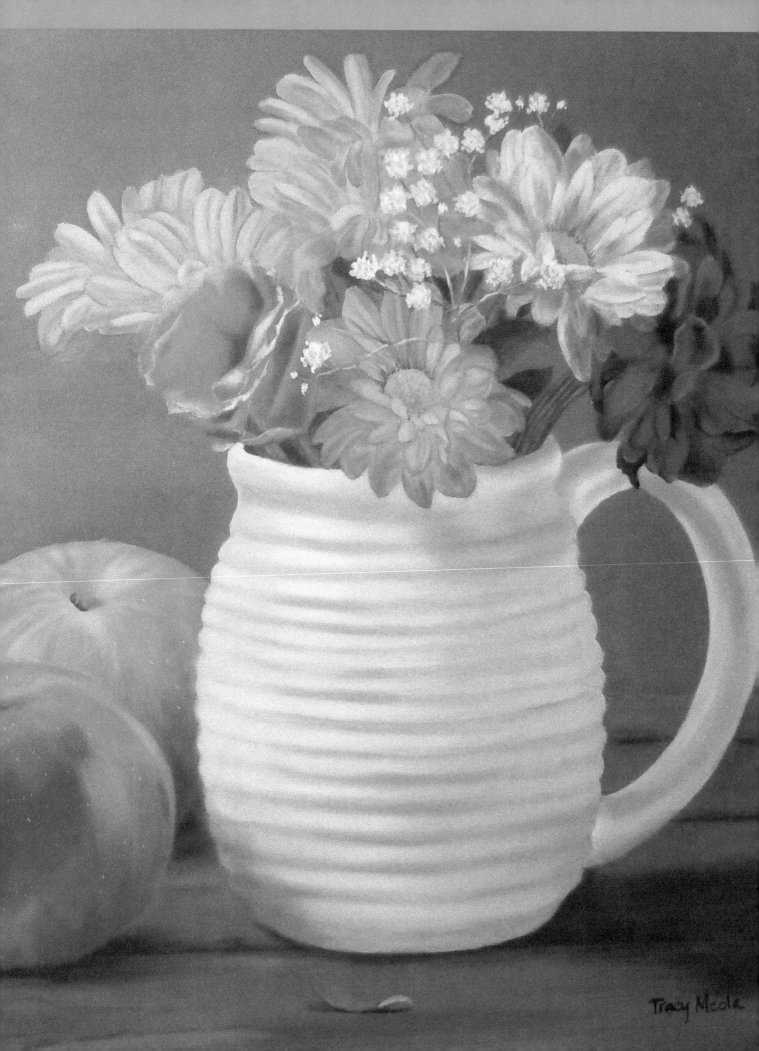

CHAPTER 5

Realism & Detail

with Tracy Meola

In this final chapter, artist Tracy Meola shares her polished, stunningly realistic style as she walks you step-by-step through five still life projects. From a bowl of fresh tomatoes to crisp apples and a cupcake that looks good enough to eat, you're sure to find pleasure in this lovely selection of artwork.

Cupcake

I enjoy painting realistic still lifes because I prefer clean edges and plenty of detail. It is a thrill when others view my work and initially think it's a photograph. To achieve this level of realism, I always start with a detailed drawing. I continue to develop my drawing as I progress, using a white charcoal pencil over dark areas and graphite pencil over light areas.

Color Palette

burnt umber light • carbon black

Hansa yellow medium • magenta • neutral gray

raw sienna • raw umber • titanium white

Mixes

Pink orchid = magenta + Hansa yellow + white

Warm black = carbon black + raw umber

Step 1 I paint the entire board with pink orchid mixed with white. While wet, I add a second coat of color, picking up white in my brush with the orchid color and painting lines along the folds of the cloth. I also blend white into the wet orchid in the bottom-left corner. When dry, I lightly draw a line separating the brown background from the tablecloth. I paint the background using burnt umber light, allowing the brown to taper off as I reach the cupcake. I add another coat of burnt umber light; while wet, I blend in some orchid mix to the upper-left quadrant of the board. I blend raw umber into the wet upper right corner, adding a bit of warm black near the right edge.

Step 2 Now I outline the cupcake, separating the frosting from the cake and indicating the drizzle. I paint the frosting with pink orchid, working around the larger chocolate drizzle. While this dries, I paint the cupcake and liner a middle-value brown, such as burnt umber light. Along the left side, I create a long shadow by first stroking a bit of water, followed by small amounts of pink orchid mixed with burnt umber. I leave the edges of the shadow fuzzy.

Artist's Tip

I prefer to develop my paintings in this order: middle values, dark values, light values, and then color reflections.
Don't try to accomplish any single element with just one application; building the values in layers will create depth.

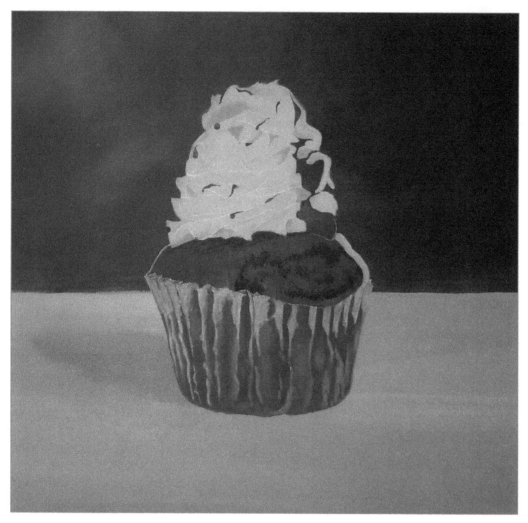

Step 3 I draw lines to indicate the folds of the paper liner and swirls in the frosting. I mix magenta and Hansa yellow medium, using this to create the deepest areas and crevices in the frosting. I use a lighter version of the pink orchid mix to create the paper liner. I add a little water to the paint to make it transparent and then paint the heavier areas toward the top of the liner. Using the mopping technique (see "Mopping Tip" below), I add paint to the lower areas of the liner. Then I add a layer of raw umber over the deep areas of the cake, dabbing for texture. I also use this paint to create a shadow on the cake under the frosting. I add tiny chocolate drizzles using burnt umber light.

Mopping Tip

Use the mopping technique to achieve an area that is soft and well blended. You will need a large flat brush for water, a smaller flat or oval brush for paint, and a fluffy mop brush for blending. When the surface is dry, moisten the area with water (A). Smooth the paint over the center of the damp area, but not too thickly (B). Quickly mop the area to smooth out the paint and blend it using the tip of the mop brush. Lightly sweep back and forth so that the color graduates from intense in the center to nothing on the outer edges. Remember not to extend the sweeping out beyond the moistened area (C).

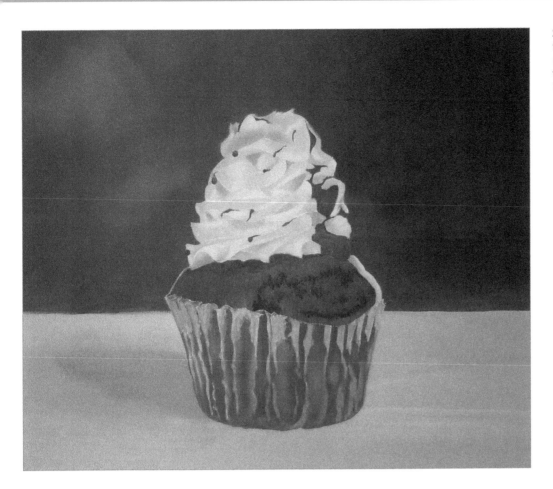

Step 4 I add lighter values to the frosting with a mix of white and pink orchid. For the dark values of the chocolate drizzle, I use warm black.

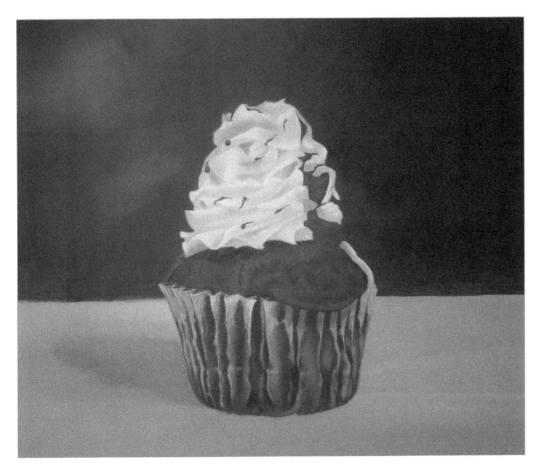

Step 5 I paint over the cake with burnt umber light, toning down the darks a bit. I add dark values to the paper liner with raw umber to create recessed areas. I also use this color to create the shadow under the blob of cake that hangs over the liner. Then I apply raw sienna to the lightest areas of the cake and chocolate drizzle. For the lightest values of frosting, I use white and a touch of pink orchid. I use this mix to lighten the paper liner, create folds on the liner, and lightly define its top edges.

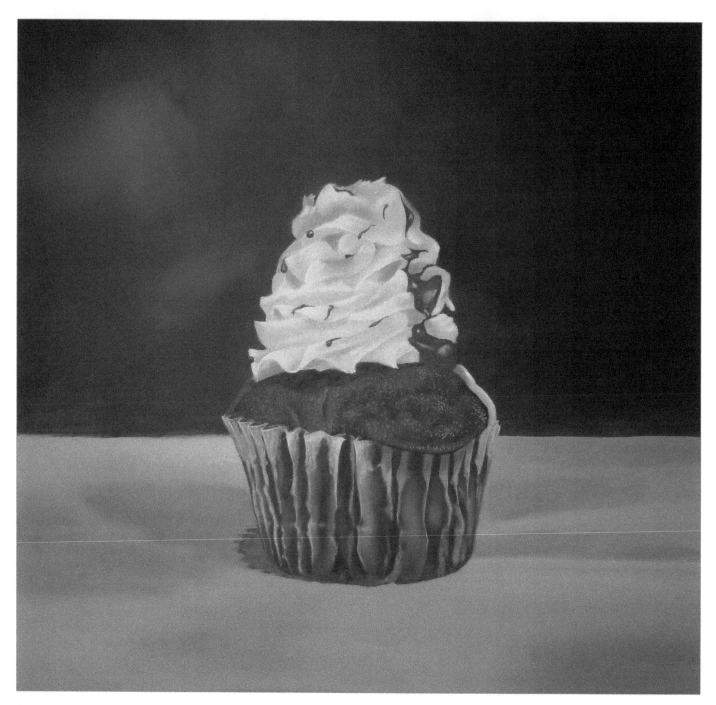

Step 6 At this point, I begin fine-tuning the piece. I deepen the dark areas of the frosting with magenta plus Hansa yellow medium and a bit of raw sienna. I deepen the dark areas on the paper liner with warm black, and I add lighter values of frosting with white. I highlight the drizzle with white and pink orchid. For larger areas, I use the mopping technique; for the drizzle, I apply dots. I add lighter values to the paper liner, mostly on the top half, using white with a small touch of pink orchid. With a loose mix of raw sienna and titanium white, I dab very small dots of highlight onto the cake, adding texture. I create some larger areas of color variation on the tablecloth by mopping on deeper areas with magenta plus Hansa yellow medium and neutral gray. For the small cast shadow at left under the cupcake, I use raw umber.

Artist's Tip

If your subject is very intricate—or if you prefer having established guidelines from the start—draw the composition first on a separate sheet of paper, and then transfer it to your board using transfer or graphite paper.

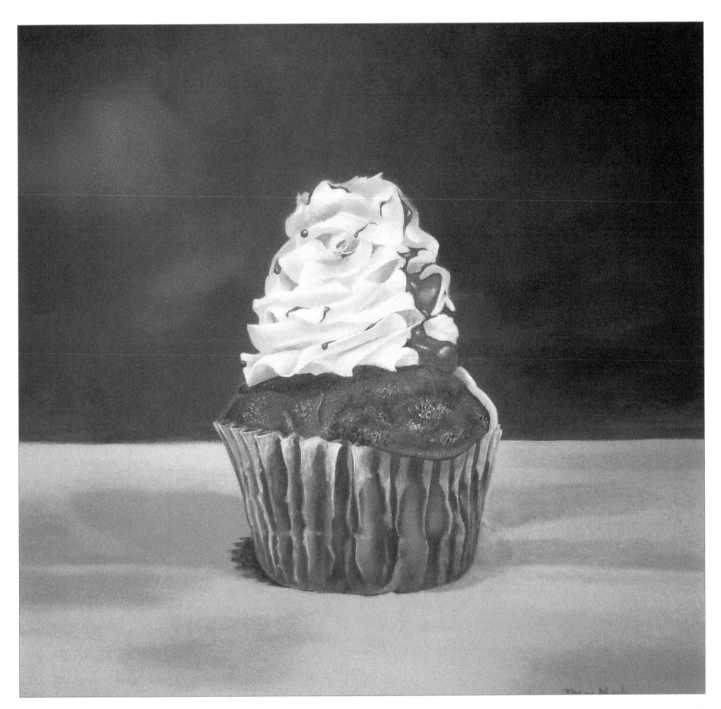

Step 7 I dab small dots of raw umber on the cake using the tip of a liner brush. I add a final highlight on the chocolate drizzle with a very light value of pink orchid, also using this color to bring light onto the tablecloth. I deepen the small cast shadow with warm black. Then I mix a light value of raw sienna and white to dot on the lightest areas of the cake. At this point, I evaluate the piece and step back to determine if I need to add any other details. To finish, I sign the painting!

Artist's Tip

To seal and protect your finished painting, add two or three coats of water-based varnish, following manufacturer's instructions carefully.

Candlestick

In this patriotic scene, learn how to create subtle shadows and tone down a bright palette with a range of grays that result in a realistic still life.

Color Palette

cadmium red medium • carbon black • neutral gray

primary cyan blue • Prussian blue • raw umber

red oxide • titanium white

Step 1 I paint the board with a cool gray mix of white and carbon black. Once dry, I measure and pencil in the background stripes. For example, use ¾" stripes for an 8" x 10" board.) Then I sketch the taper candle, candleholder, and metal tag.

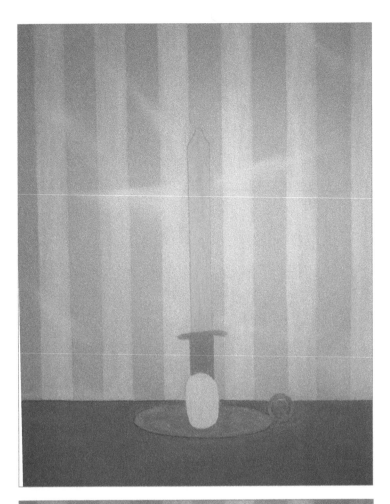

Step 2 I lighten the background mix with white to paint the white stripes. Then I use primary cyan blue to paint the candle. For the candleholder, I use a warm, neutral, medium gray mix, adding a touch of raw umber if necessary. I paint the tag using the original background mix. For the table, I use red oxide and a touch of raw umber. Using the mopping method (see "Mopping Tip" on page 112), I lightly blend in the sags of the background with a lighter value of the "white" used for the background stripes.

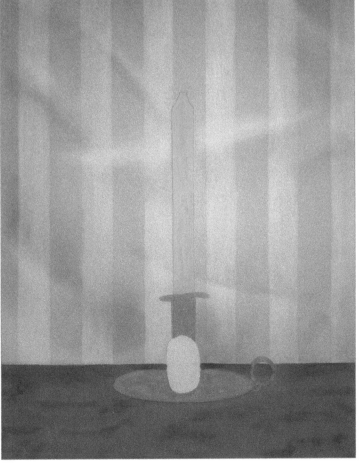

Step 3 Using neutral gray and the mopping method, I deepen the sags by adding paint opposite the lighter value added in Step 2. I create some gnarls in the wooden table by dabbing in areas of raw umber. Once dry, I use raw umber to deepen the table behind the candleholder, where the table meets the background.

Step 4 I use cadmium red medium to paint the red background stripes. Then I add dark values to the candleholder, starting with raw umber and adding black and neutral gray to deepen it further. I paint the cast shadow of the candle on the background with neutral gray, keeping it thin where the light in the background is strongest. I deepen the left side of the table with raw umber.

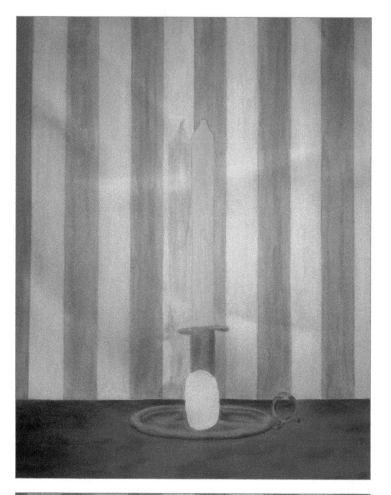

Step 5 To suggest rust, I add some red oxide to areas of the candleholder. I place the dark and light values on the front of the holder to create the indentation; then I highlight it with neutral gray and white. Noticing that areas of the candle shadow are a little darker, I deepen them with touches of black and neutral gray. I deepen the darker areas of the taper candle with Prussian blue. I paint the wick with light gray at the base, and then I apply black the rest of the way up, ending with a touch of red oxide at the tip. I apply a layer of dark values over the metal tag using a medium dark gray mix. I continue deepening by adding more black to the mix with each layer.

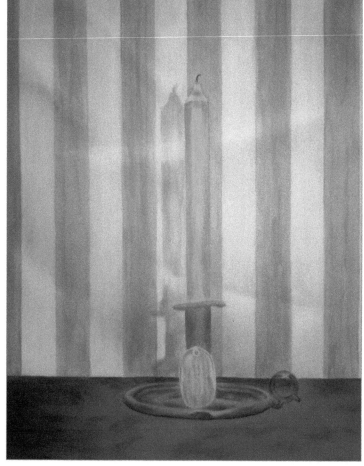

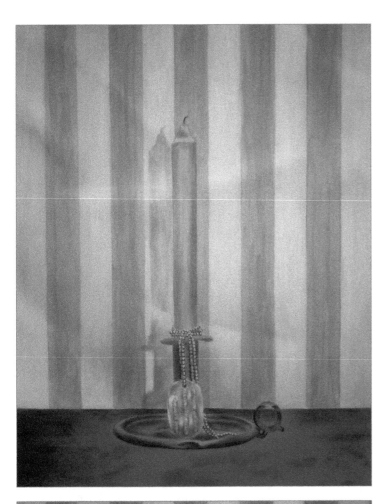

Step 6 I paint the chain with dots of a middle-value gray. I add water to black and use this to deepen areas between the chain beads and parts in shadow. I highlight the metal tag with white and a touch of black. Once dry, I add more white and lighten the lightest areas. I mix black and Prussian blue to deepen the candle on the right side.

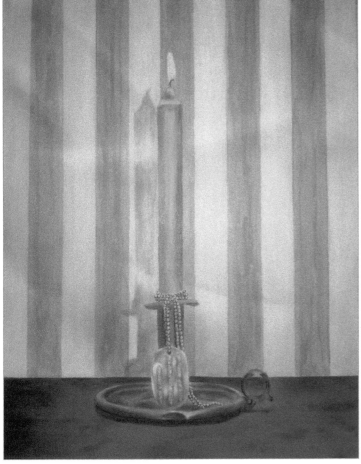

Step 7 I further highlight the candleholder by adding more white to the mix. I also add more light touches of red oxide to the holder. I highlight the taper candle with primary cyan blue mixed with white. To create the cast shadow on the table under the holder, I use thinned raw umber plus black. I paint the flame with white and a tiny touch of red oxide.

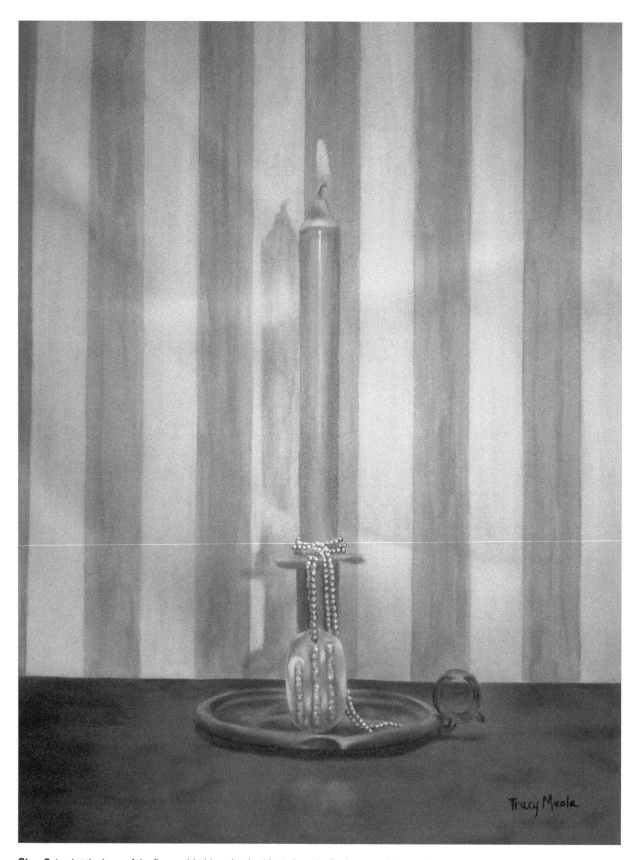

Step 8 I paint the base of the flame with thinned red oxide. I place the final center shine on the taper candle with white, letting it fade out near the bottom. I highlight the beads of the chain with white and a tiny touch of black. Once dry, I create the lightest areas with white. I add the shine reflection on the table with middle-value gray using the mopping technique. (See "Mopping Tip," page 112). When this dries completely, I add more white to the gray mix and brighten the shine closest to the candleholder. I step back, evaluate, and fine-tune where necessary.

Step 9 I brighten the red stripes with two coats of cadmium red medium, deepening the areas of sag with a touch of black. I add white to the brightest areas of the white stripes, tapering it off where the cloth goes into shadow. Then I brighten the flame tip with white. I add a touch of white to primary cyan blue and brighten the center of the taper candle. To brighten the candle's shine, I apply a line of white. I also add more dots of white to lightest areas of the chain. To finish, I sign the painting and seal it with a water-based varnish.

Bottles & Flowers

This nearly monochromatic palette of blues, greens, and grays will allow you to focus on form and reflections without fussing too much over color. A simple background emphasizes the subtle shifts of value within the glass and allows the flowers and dark bottle to "pop" as the focal point.

Color Palette

burnt umber light • carbon black • Hansa yellow

Hooker's green • neutral gray

permanent green light • primary cyan

Prussian blue • raw sienna • titanium white

Step 1 The key to painting glass is working in thin, transparent layers. Planning ahead is essential. I begin by painting the board white, keeping it smooth and avoiding ridges. This step may require multiple coats. I load a large flat brush with primary cyan and use the chisel edge to haphazardly swipe blue slashes across the upper three-quarters of the board.

Step 2 I pick up medium gray in my brush and wipe off excess paint on a paper towel. I swipe a few dry gray slashes on the board. When dry, I paint over the entire board again with white to quiet the intensity of the blue and gray, pushing them into the back-ground. You may need to add an additional coat of white.

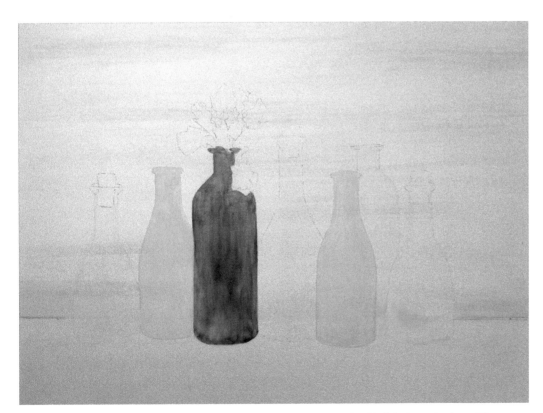

Step 3 I measure three-quarters of the way down from the top of the board and lightly draw a horizontal line across the board. Then I outline the bottles with pencil, positioning them a little lower than my horizontal line. Next I thin permanent green light with water and wash light color over the three clear bottles at right as well as the bottom of the bottle at left. When dry, I add more color to the areas with thicker glass or where another bottle shows through. I wash over the frosted bottles with cyan and white. I use this color to deepen the background where it meets the table. I also add this color inside the clear bottles. For the dark blue bottle, I use a mix of Prussian blue and gray. With the bottles established, I erase the pencil lines.

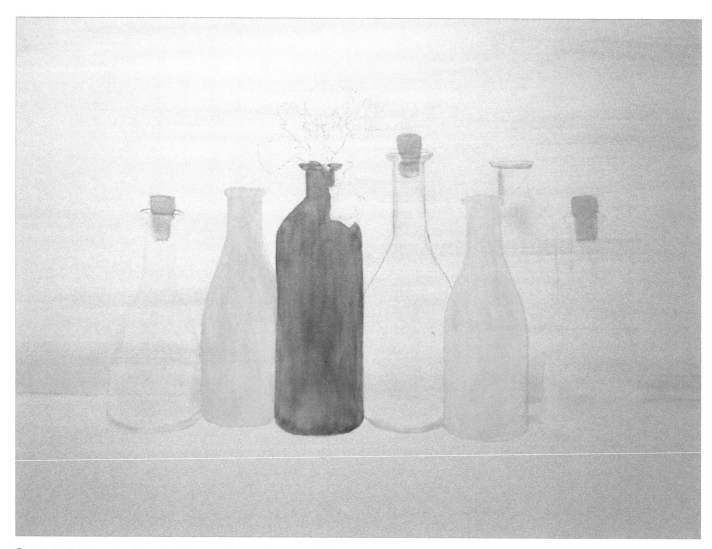

Step 4 I paint the corks with a mix of Hansa yellow, raw sienna, and white. I create shadows and suggest deeper areas of glass with a mix of permanent green light and Hooker's green.

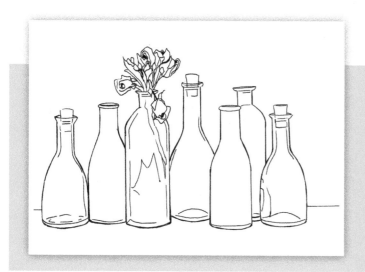

Artist's Tip

If you prefer working with established guidelines from the start, draw your composition on a separate sheet of paper, and transfer it to your painting surface with graphite paper. This allows you to reposition it and trace guidelines as needed.

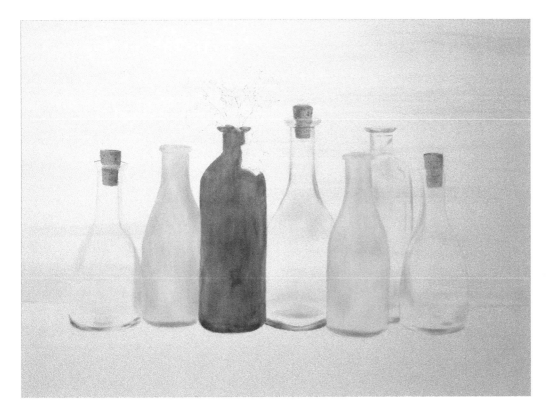

Step 5 I add another coat of blue to the frosted bottles and then add darker areas with cyan blue. I start defining the bottles using a liner brush and continue applying slightly darker values to all the bottles. I deepen the thick bottom glass of the bottles with colors from my palette. I add dark specks on the corks with burnt umber light and deepen areas of shadow.

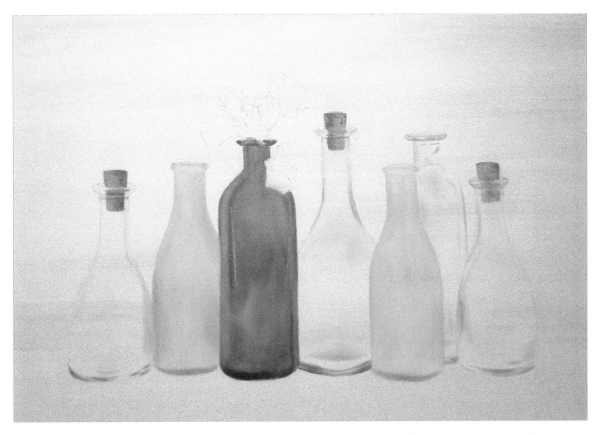

Step 6 I continue layering the darker values. I add black to the Prussian blue mix for the dark blue bottle. To create shine and transparency, I place lighter blue in the lower-middle area of the bottle.

Step 7 I paint the flower stems inside the bottle with Hooker's green. I add white to the first cork mix and apply light specks on the corks. Then I apply my first layer of white shine on the bottles. For the frosted bottles, I use the mopping method; for the other bottles, I add more defined strokes with a flat brush. I paint the flowers with a mix of white plus a little raw sienna (which makes a cream color). I paint the stems and leaves with Hooker's green plus a touch of the raw sienna mix.

Tracy Meola

Step 8 I apply another layer of white over the bottle highlights. I add dark values to the flowers by adding more raw sienna to the first mix; then I further deepen with raw sienna. Finally, I add burnt umber and raw sienna to the darkest areas. I stroke white highlights on the lightest areas of the petals. For the dark values on the stems and leaves, I use Hooker's green and a touch of black for more contrast. I add lighter values with Hooker's green plus my Hansa yellow mix. If they need more lightening, I add more Hansa yellow. I paint shadows on the table under the bottles with cyan, gray, and a touch of Prussian blue. I re-evaluate everything and fine-tune where necessary. To complete the painting, I sign it, let it rest, and add a protective finish.

Bowl of Tomatoes

One way to make your painting "pop" is to surround your main subject with neutral colors. In this scene, the red-orange of the tomatoes stands out against the creams and light browns of the bowl, cloths, and wood.

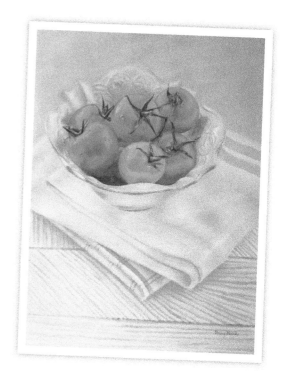

Color Palette

cadmium orange • chromium oxide green

Hooker's green • napthol red light • medium gray

raw sienna • raw umber • red iron oxide

titanium white

Mixes

Mud = white + raw umber + a touch of napthol red light

Shadow = napthol red light + a small amount of black

Orange tone = cadmium orange + a touch of gray

Mustard = cadmium yellow + raw sienna

Step 1 I use a small roller to cover my entire painting board with white. Once dry, I place white and the mud mix on my palette, roll the two together, and then roll over the board. The result is a background texture with a vaguely uneven appearance.

Artist's Tip

If you want to work with an established sketch, draw the composition on a separate sheet of paper, and use graphite paper to transfer it to your painting surface.

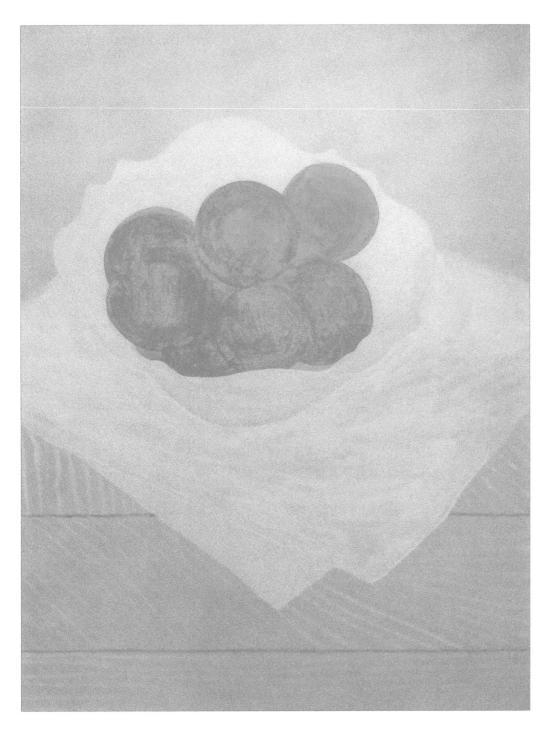

Step 2 Now I outline the elements. I use a smooth flat brush to paint the bottom cloth and dish with white and a touch of the mud mix, creating a soft white. I paint the top cloth with white and a touch of medium gray to create a very soft gray. I paint the tomatoes with the orange tone mix. Using the same mix that I used for the dish, I use a liner brush to paint the lines of the table's wood grain. For the separations between the planks of wood, I use the mud mix.

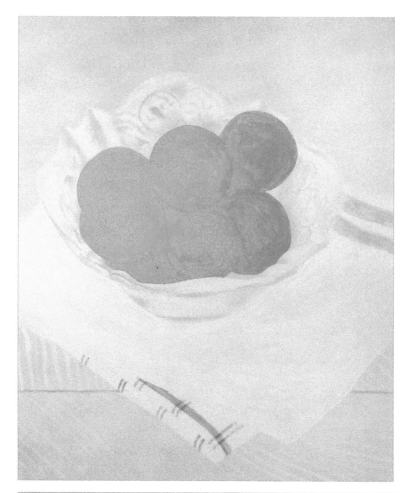

Step 3 I paint the stripes on the bottom cloth with napthol red light. The stripes on the top cloth are a mix of white, napthol red light, and orange tone. I keep them light to push them into the background. (If they seem too bright, you can quiet them down with a layer of white paint.) I use a liner brush to add the design on the dish with mud plus a touch of white. I also use this mix to add dark values to the dish.

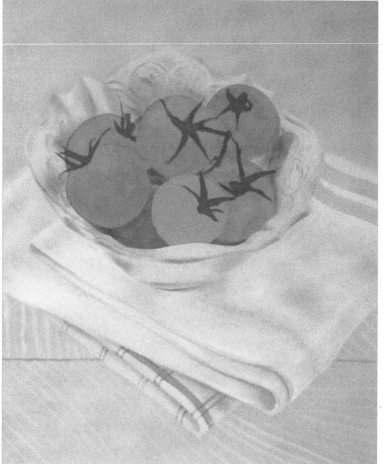

Step 4 With the mopping method, I apply dark values to the cloths, suggesting fold lines, indicating where the two cloths meet, and showing lower-lying areas of the top cloth. For the bottom cloth, I use the mud mix; for the top cloth, I use a mix of white, gray, and the mud mix. I deepen the darkest areas on the dish with the shadow mix plus mud and a touch of white (which will result in a deep gray mix). I paint the two tomatoes on the right with the orange tone mix plus red iron oxide. I paint the three tomatoes on the left with napthol red light plus the orange tone mix. I apply the orange tone mix alone over the bottom center tomato. The tomatoes underneath are varied values of napthol red light plus a touch of black and the orange tone mix. I paint the stems and leaves with chromium oxide green.

Step 5 I add highlights to the cloths and dish using white. I build these slowly, applying them twice to some areas and three or four times to the brightest areas. Reflect a hint of color on the dish behind the tomato at right with thinned napthol red light. I use a liner brush to lightly and loosely dab on the dark ceramic edges with black toned down with the mud mix. I apply dark values to the tomatoes by first adding the shadow mix to the tomato color. Then I apply the shadow mix over the darkest areas. I add cadmium yellow to the orange tone mix and add a lighter value to the tomatoes (the lights—not the white shines).

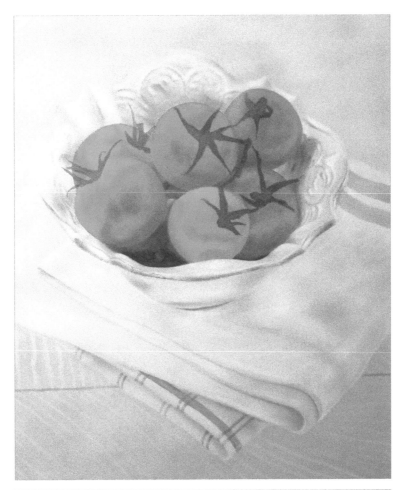

Step 6 Now I bring the tomatoes to life by adding shine marks with white. I stroke directly over the green where necessary, as I will develop the sepals in subsequent steps.

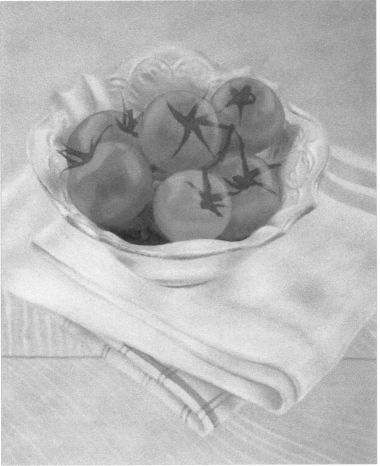

Step 7 In this step, I complete the tomatoes, stems, and leaves (see detail below). I add darker lines of value to the table boards with the mud mix plus white. Then I add some lines with the mud mix, followed by mud mixed with a touch of red iron oxide. I keep all my lines watery and light. I also go over the plank, separating lines with the mud and shadow mixes.

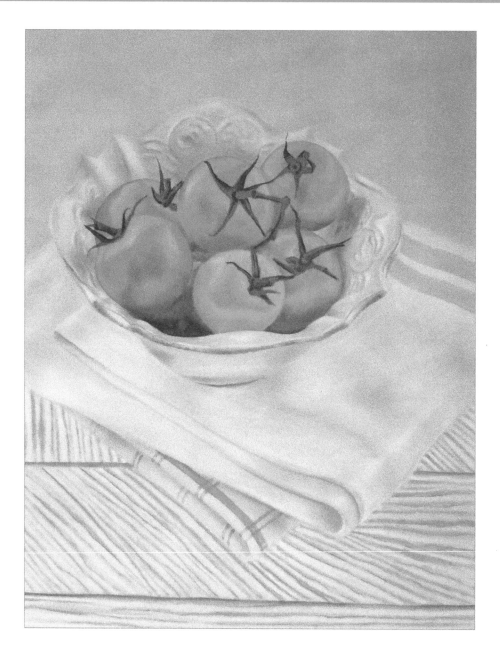

DETAIL

I brighten the tomato shines with more white. I repaint the stems and leaves with chromium oxide green. I add a little water to Hooker's green and use a liner brush to apply the dark value to the stems.

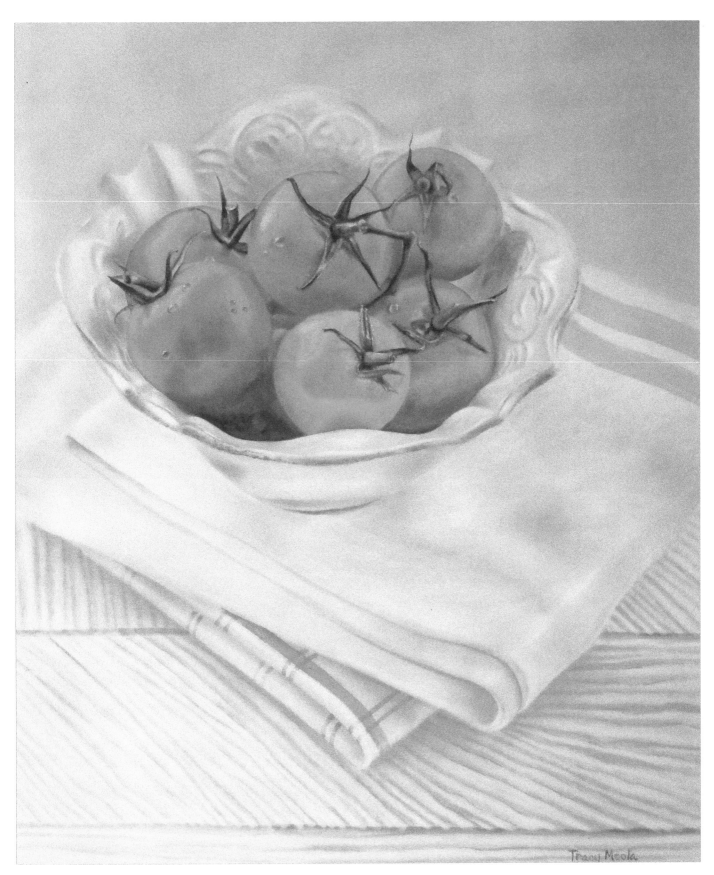

Tracy Meola

Step 8 I wash white over the left side of the painting, on the background, and over the table boards, tapering it off. I apply the darkest value to the stems and leaves with Hooker's green plus black. I apply lighter values to the stems and leaves with the mustard mix plus chromium green oxide. I add more mustard to the mix for the lighter areas. I add orange reflections on areas of the stems, followed by white shines to the stems and leaves. I add the cast shadow of the cloth on the table using the mud mix thinned with water. I deepen areas of it with thinned mud and the shadow mix. For the water droplets, I start by painting them with one coat of orange tone mix (not opaquely). I add darker areas of droplets using the shadow mix. I add some of the shadow mix to the outside of each droplet as well, suggesting its shadow. I add a small amount of mustard to the lightest side of the larger droplets using a liner brush. Then I add the final shine with white. Using the shadow mix, I add cast shadows on the tomatoes under the leaves.

Floral Scene

In this painting, I focus on creating depth by painting in several layers. As I often do, I begin with middle values, followed by dark values and then light values. I finish by adding color reflections.

Color Palette

alizarin crimson • burnt umber • cadmium orange • cadmium yellow • Naples yellow

Mars black • quinacridone magenta • quinacridone red • sap green • titanium white

Mixes

peach = cadmium orange + white

orange tone = cadmium orange + a touch of gray

dirty white = white + small amount of cadmium yellow + a touch of gray

light green = cadmium yellow + sap green

taupe = white + a small amount of burnt umber + a touch of cadmium yellow

Sketch Before I begin painting, I work out my composition with a line drawing.

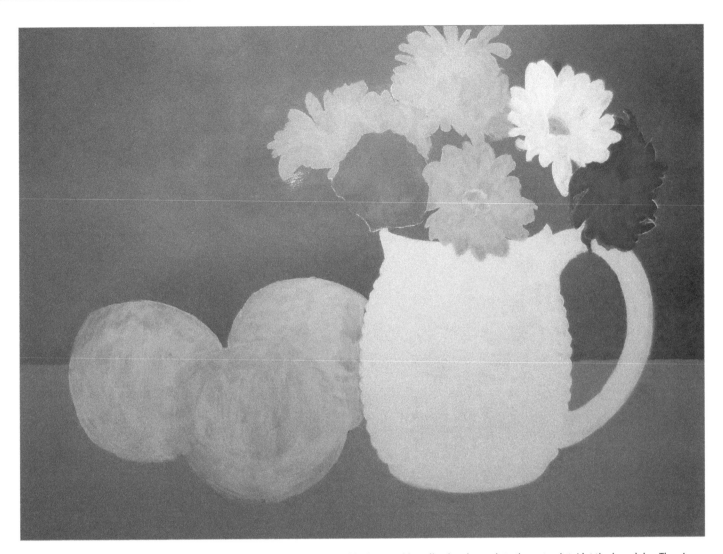

Step 1 I paint my board with neutral gray. Once dry, I paint it gray again, this time working alizarin crimson into the wet paint. I let the board dry. Then I draw the outline of the pitcher, flowers, and apples. I paint the apples with Naples yellow, the pitcher with the dirty white mix, the orange daisies with the peach mix, and the pink daisy with white and alizarin crimson. I paint the burgundy flower with alizarin crimson and a touch of white; then I paint the rose with quinacridone magenta and white. I paint the flower center with Naples yellow. To paint the table, I use a mix of burnt umber, white, and a touch of cadmium yellow.

Step 2 I add a light green mix to the apples near the stems and on the bottom of the front apple. Then I paint the stem of each apple: sap green for the apple at left, burnt umber for the middle apple, and Naples yellow mixed with burnt umber for the apple at right.

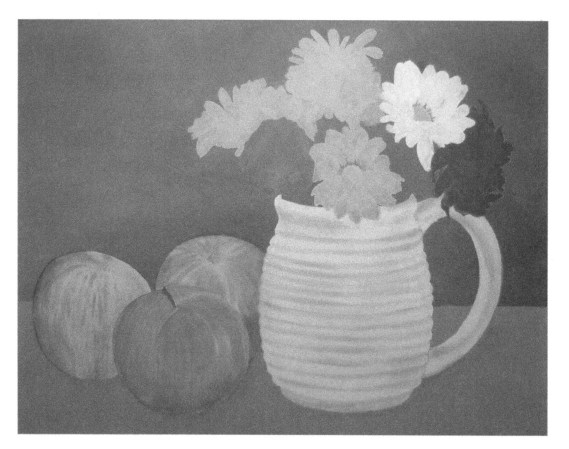

Step 3 I use the taupe mix to add dark values to the pitcher. Using a liner brush, I tap sap green mixed with a touch of black around the flower centers. I mix quinacridone magenta and a touch of white for a bright pink and apply this to the red areas of the apples. I use the chisel edge of a flat brush to touch on the striped areas of red. For the larger areas, I use the mopping method (see "Mopping Tip" on page 112) so the transition from pink to yellow isn't too harsh. To deepen some of these areas, I apply quinacridone red.

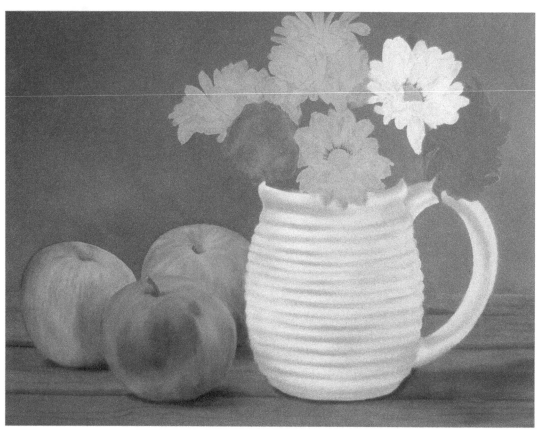

Step 4 I mix burnt umber and quinacridone red for the darkest areas of the apples, including the centers. Where need-ed, I deepen some areas with pure burnt umber. I tap brown into the scaly area of the bottom-center apple with the chisel edge of a flat brush, using a mixture of sap green and burnt umber. I add a touch of black to the taupe mix and apply the darkest values on the pitcher. Once dry, I apply highlights on the pitcher with white in several layers. I brush raw sienna onto the table to warm up the areas that are mid-value. I use a liner brush with burnt umber to create lines in the table. I add shadows on the table with burnt umber.

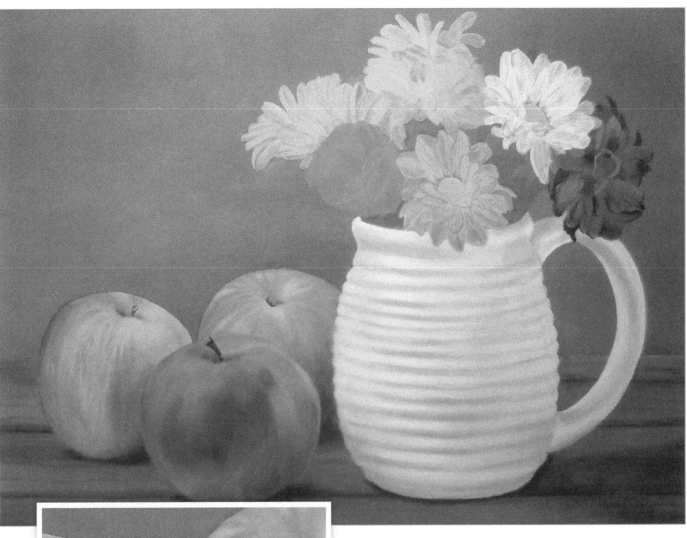

Step 5 I highlight the apples with white mixed with a touch of Naples yellow. I give form to the apple stems using dark and light values, tapping on the color for texture. I put tiny flecks of the dirty white mix on the front stem. I begin layering dark values on flowers. For the orange daisy, I use the orange tone mix. For the pink daisy, I use alizarin crimson and white. For the burgundy flower, I use alizarin and black. I use quinacridone magenta and a touch of white for the rose. Then I loosely add greens among the flowers using sap green.

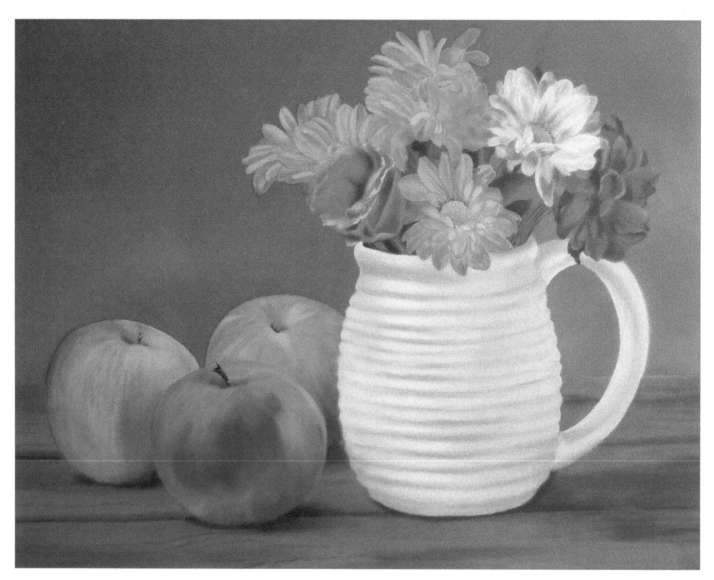

Step 6 I add some alizarin crimson and white to the orange flower. Then I add darker values in areas of shadow with the orange tone mix, adding burnt umber to darken. I add lighter values using cadmium yellow, followed by cadmium yellow mixed with white. To deepen the areas of shadow within the rose, I use alizarin crimson followed by alizarin crimson mixed with black. I add highlights with quinacridone magenta mixed with white. Within the pink daisy, I add areas of shadow with gray. I add deeper pinks from my palette as needed. I add light petals to the burgundy flower with quinacridone magenta, and then I add a bit of the dirty white mix to the magenta. For the flower centers, I add light green (for a dark value), followed by cadmium yellow and white. I use colors from my palette to deepen flowers where desired and to create color harmony throughout the painting. I also use a liner brush to define petals and add ridges to the petals. For dark values within the flower greens, I mix sap green with black.

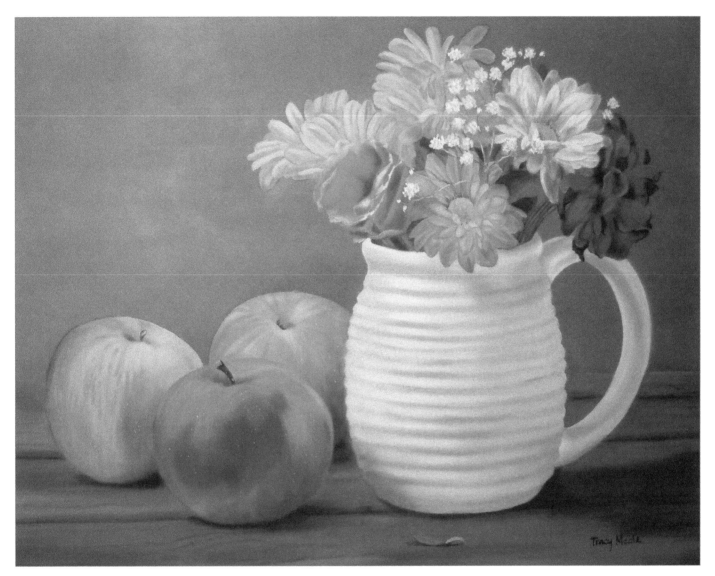

Step 7 I add specks to the apples with a liner brush and thinned Naples yellow. While still wet, I tap the specks with my finger to blur and dull the color. I paint the baby's breath flowers by tapping the dirty white mix onto the painting board with the liner brush. I add a touch of sap green into the mix for darker areas. Then I add a touch of white to dirty white and tap lighter areas. I pull the stems with a liner brush using the light green mix. I add darker values to the stems with sap green, followed by highlights using the light green mix and white. I deepen the table shadows with burnt umber and black. I paint the fallen petal on the table using colors from the palette. I don't forget to add a cast shadow under it with burnt umber. I evaluate the painting and sign once I am satisfied. To protect the finished piece, I apply two to three coats of water-based varnish, following the manufacturer's instructions.

About the Artists

Varvara Harmon of Windham, Maine, is an award-winning multimedia artist who has mastered oil, acrylic, watercolor, silk painting, and ink and pencil drawing. Her work has been juried into national and international exhibitions and is in private collections around the world. Varvara's work has been published in *International Artist* and *American Artist* magazines, as well as in *The Best of America Oil Artists* book in 2009 and *The Best of World Landscape Artists* in 2012. Varvara is a member of the International Guild of Realism, Oil Painters of America, and Landscape Artists International. Varvara is currently represented at several art galleries across the Northeast and teaches workshops and classes in acrylic, watercolor, and oil. Visit *www.varvaraharmon.com* to learn more.

Elizabeth Mayville of Grand Rapids, Michigan, is a professional artist and illustrator. Since earning her BFA in 2006, she has become increasingly interested in the idea of "home" and all the seemingly small bits of life that bring us comfort and a sense of stability.

Tracy Meola of Plaistow, New Hampshire, is a professional artist who specializes in still-life acrylic paintings. As a child, Tracy loved crayons and coloring books and eventually graduated to sketchpads and pencils. She majored in advertising and illustration at The Art Institute of Fort Lauderdale, but she still considers herself self-taught because, lacking confidence, she left college and entered the business world, leaving art behind. Ten years passed before she picked up a paintbrush, but her love of painting was instantly restored. Life experience gave her the confidence she previously lacked, and in 1991, she began painting and teaching professionally. Tracy paints with acrylics using her own adapted technique of lightly applying multiple layers of paint with the use of water, which creates a soft, blended look in her artwork. Tracy chooses elements for her still-life paintings that have texture and light, which is why many of her subjects include glass or candles. She wants her artwork to give others a sense of home, peace, joy, and nostalgia.

Janice Robertson of Fort Langley, BC, Canada, has received many awards, including three bronze medals in the Federation of Canadian Artists 2000 Signature Members show, the Margaret and William Foley Award at the 2001 Adirondacks National Exhibition of Watercolors in New York, and the Foreign Award in the 2004 Houston Watercolor Society exhibition. Janice holds senior Signature membership in the Federation of Canadian Artists, Landscape Artists International, the Northwest Watercolor Society, and Artists for Conservation. She is author of Walter Foster's *Acrylic Basics*.

Index